DRAWING FOR EVERYONE

Classic and Creative Fundamentals

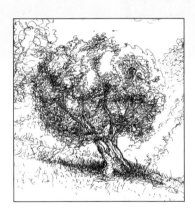

BY BRUCE WALDMAN

PETER PAUPER PRESS, INC.
White Plains, New York

PETER PAUPER PRESS
Fine Books and Gifts Since 1928

OUR COMPANY

In 1928, at the age of twenty-two, Peter Beilenson began printing books on a small press in the basement of his parents' home in Larchmont, New York. Peter—and later, his wife, Edna—sought to create fine books that sold at "prices even a pauper could afford."

Today, still family owned and operated, Peter Pauper Press continues to honor our founders' legacy—and our customers' expectations—of beauty, quality, and value.

Designed by Heather Zschock

Text and illustrations copyright © 2014 Bruce Waldman

All artwork by author, unless otherwise noted.

p. 13, top right: photo © Bichlet Michael/Shutterstock.com

Peter Pauper Press, Inc.
202 Mamaroneck Avenue
White Plains, NY 10601

ISBN 978-1-4413-1597-7
Printed in China

7 6 5 4 3 2 1

www.peterpauperpress.com

DRAWING FOR EVERYONE

Classic and Creative Fundamentals

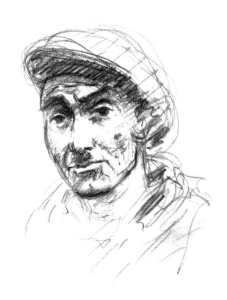

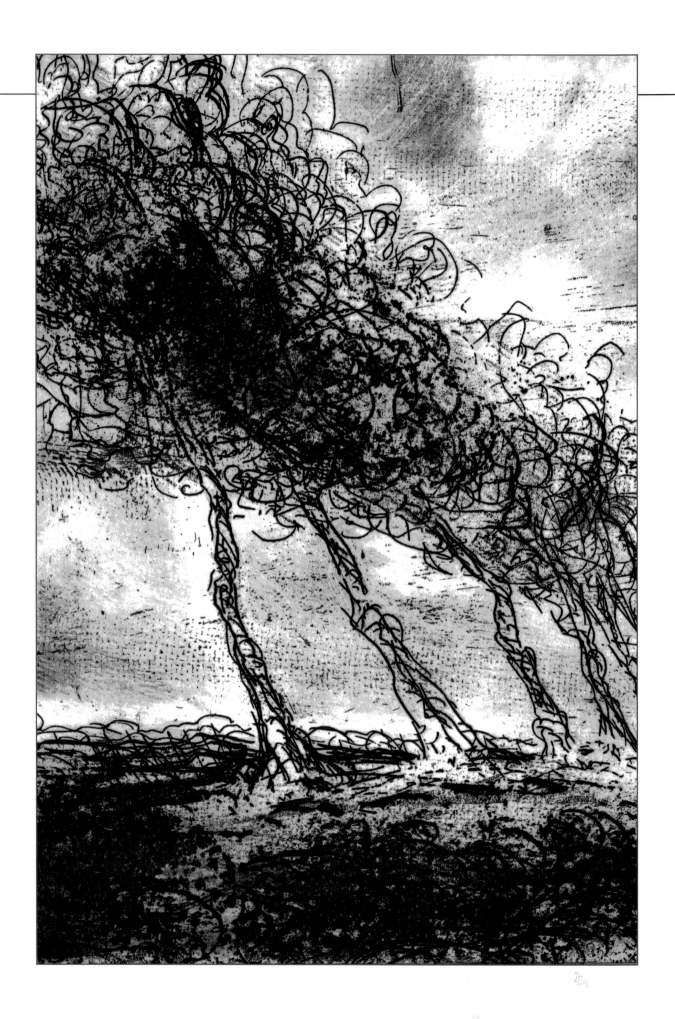

CONTENTS

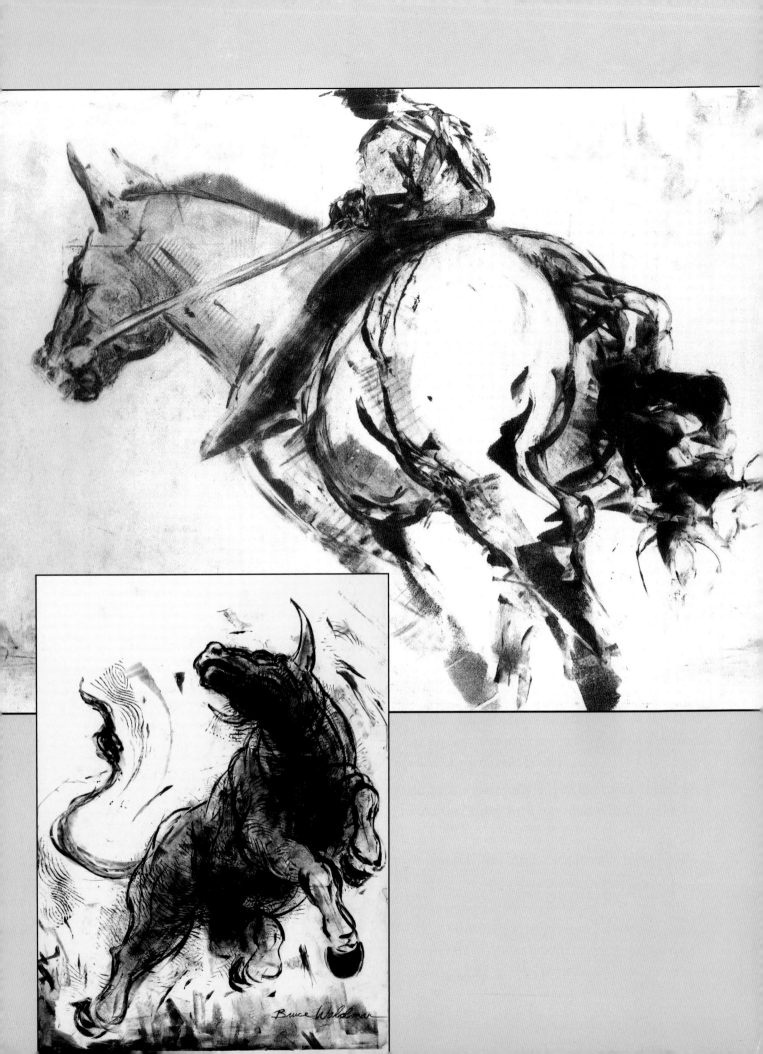

INTRODUCTION

I like to tell my students on the first day of class that if they enjoy looking at art, and have enough hand-eye coordination to thread a needle, they can learn how to draw.

Many of them look at me with disbelief when I say this, and later find it to be the truth.

I know that the methods I teach work from observing hundreds of students through the years. Even those who started out with very little experience learn to draw well. Drawing is a skill, just like tennis, not magic. It really is a visual language, and like any language, it has simple structural rules. Learning the language of drawing frees you to express your inner feelings on paper.

The systems I developed for learning to draw have evolved over my 30 years as a teacher to what I will outline in this book. Many lessons constitute streamlined versions of the classical methods taught during the Renaissance. They've stood the test of time, and great master artists from many eras have used them to create some of the world's best-known pieces of art.

There are really only four basic rules to keep in mind when drawing most objects, and you'll learn them in the first chapter. I always tell my students that these rules are simpler than a first-grade math lesson, and they can all learn to make structurally sound drawings with a little practice. Once the rules become second nature, you can tap into your own unique form of creative expression.

It is important to keep in mind that these rules are tools only. The systems I teach are there to help artists create an illusion of reality, and following them will lead you in the right direction, especially when you're starting out. But they needn't be absolutely and without fail obeyed. In the end, students' goal should be to focus on whether their art conveys what they want it to convey, not whether it complies perfectly with the rules of drawing. Artists can deviate from the norm, and don't have to draw reality exactly as they see it. But understanding how to draw things as they appear will help you exaggerate, embellish, and stylize your subjects to the most interesting and powerful effect.

The systems are not an end in themselves. The purpose of art is to express your personal vision, and the tools in this book will help you do that.

Bruce Waldman

SUGGESTED MATERIALS

Most of the drawing exercises in this book can be done with any pencil and sketchbook, but you'll get more out of them—and enjoy them more—if you experiment with different drawing media, types of paper, and other tools. Below you'll find a list of materials that may prove useful in the chapters ahead.

FOR DRY MEDIA DRAWING:

* A complete set of **H** (hard) and **B** (soft) pencils for light and dark lines
* A small **drawing pad of white paper** (8" x 10" or 9" x 12") that can easily be carried around for sketching on the spot in pencil
* A **kneaded eraser** and a **hard eraser**
* Sticks of **vine charcoal** and **condensed charcoal**
* A good set of **Conté crayons** and/or **Conté pencils**, which come in black, brown, and white
* A larger **newsprint pad** (18" x 24") for charcoal and Conté crayon drawings
* **Pastels** and/or **colored pencils**
* A **pad of textured pastel or charcoal paper** for more finished drawings and for drawing in color
* If you're willing to invest a little more, **Stonehenge paper** is a high-quality all-purpose paper for finished drawings, pastels, prints, watercolors, or colored pencils.

PEN AND INK, AND BEYOND:

* A set of at least **three pen points** for calligraphy and ink linework (**very thin**, **thin**, and **medium** point sizes to vary the weight of your lines)
* A **crow quill pen** with point and handle for super fine linework
* A bottle of **permanent India ink**; black is essential (Super Black India Ink is the best), but brown is also suggested
* A set of **watercolors and brushes** for color washes over pen and ink
* A set of **watercolor pencils**
* **Heavy paper for finished works**, such as illustration board (Bainbridge No. 172 is suggested), poster board, Bristol board, any other board with a smooth wax-coated surface, or hot press watercolor paper

AUTHOR'S NOTE: A number of my finished works printed in this book are etchings or monotypes. You might want to take a printmaking class if you like the look of these pieces.

CHAPTER 1
THE FOUR RULES

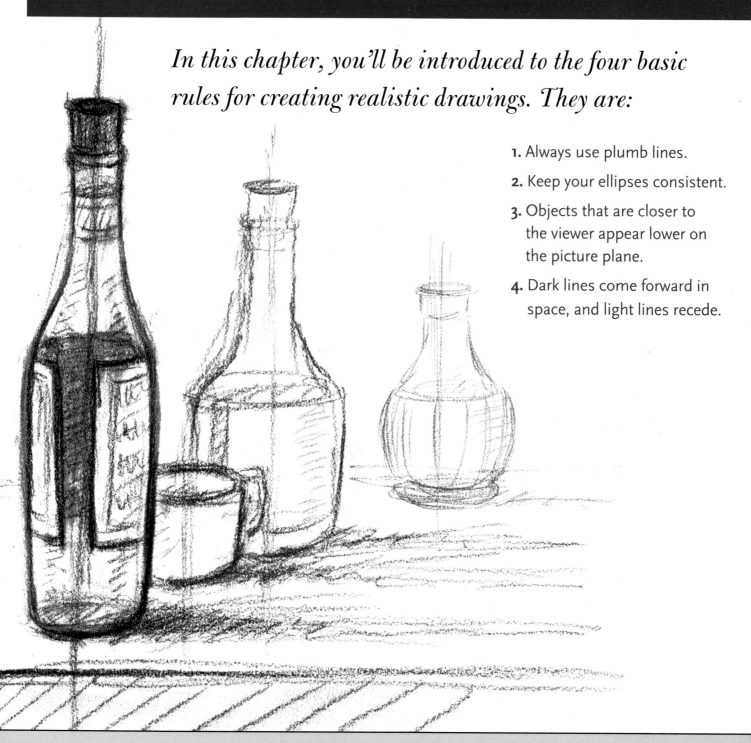

In this chapter, you'll be introduced to the four basic rules for creating realistic drawings. They are:

1. Always use plumb lines.

2. Keep your ellipses consistent.

3. Objects that are closer to the viewer appear lower on the picture plane.

4. Dark lines come forward in space, and light lines recede.

PLUMB LINES AND ELLIPSES

RULE #1: Always use plumb lines.

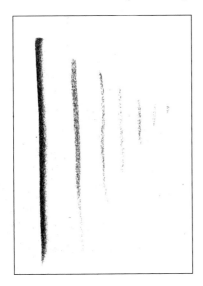

A **plumb line** is a guideline that runs through the center or central axis of any object. Plumb lines are the most critical element in structural drawing. When sketching simple objects especially, always draw your plumb line first. Then, draw the object so the plumb line runs through its center. This will give you a visual guide so that the object does not lean to the left or right.

RULE #2: Keep your ellipses consistent.

An **ellipse** is a circle or oval. In drawing, you will often use oval ellipses to represent the ends of cylindrical objects—the rim of a mug, for instance—viewed from the side. This may seem like a very specific thing to learn right off the bat, but it's the foundation for techniques that can help you draw nearly anything. For now, we'll focus on simple uses of ellipses.

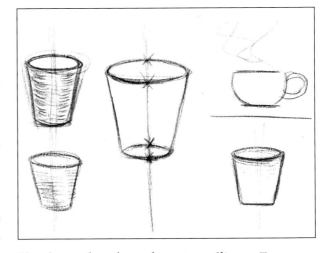

For our purposes, cylindrical objects like cups, bottles, and vases contain at least two ellipses: one at their base, and one at their rim. When depicting simple objects with straight edges like cups, you'll only need to draw those two ellipses. For more complex objects like bottles and vases, you'll want to draw a few more to keep everything symmetrical. As a rule of thumb, whenever the object widens or narrows, draw an ellipse.

DRAWING TIP: When you're drawing cups and bottles that aren't transparent, the far half of some ellipses will be hidden from view. **Lightly draw the whole ellipse anyway when you start your sketch**, and erase the part you can't see later. It will make figuring out whether your ellipses are consistent easier.

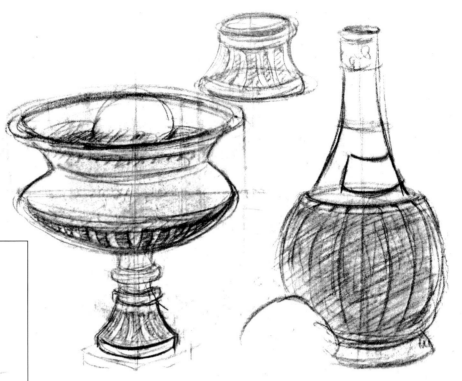

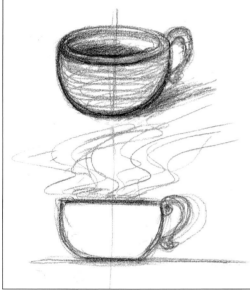

It is crucial to keep the width and shape of your ellipses consistent, so that they look like they are viewed from the same angle. When viewed from certain angles, the top and bottom of a cup can appear to be straight lines if they are consistent with each other, as in the mug illustration to the left.

DRAWING TIP: Looking at or imagining a Slinky toy may help you visualize ellipses, as the toy's spiral consists of ellipses that run from top to bottom.

EXERCISE: Drawing a cup

Follow the steps below to draw a simple cup. If you have a real cup in front of you, try drawing it afterward!

1. Draw a vertical plumb line.

2. Draw a series of ellipses around the plumb line without lifting your pencil and in a continuous motion.

3. Draw the two sides of the cup and, after making sure they're consistent, darken the ellipses that form the cup's base and rim.

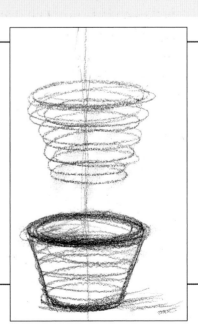

USING SECONDARY PLUMB LINES

We already discussed the use of a plumb line as an axis running through an object's center. You can also use a few **secondary plumb lines** to make sure everything in your drawing aligns correctly. These should be drawn at a right angle (a 90° angle) to the central plumb line, and will help you keep your ellipses from tilting. In the illustration below, you can see that the middle bottle top doesn't look realistic because the horizontal plumb line isn't drawn at a right angle to the main vertical plumb line.

This is a right angle.

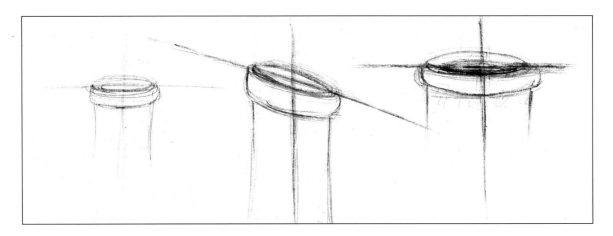

HISTORICAL NOTE: People have used plumb lines since ancient times to determine straight and vertical lines. Because there were no levels back then, early architects and engineers would tie a rock or a weight (the latter usually made of lead, which is *plumbum* in Latin) to a string and suspend it until it stopped swinging back and forth. They would then hold it against a wall or other vertical surface as they constructed it, to ensure that it was straight. Artists used the same tool as a visual guide, or plumb line, through the center of any vertical object they drew. Versions of this tool are still used today.

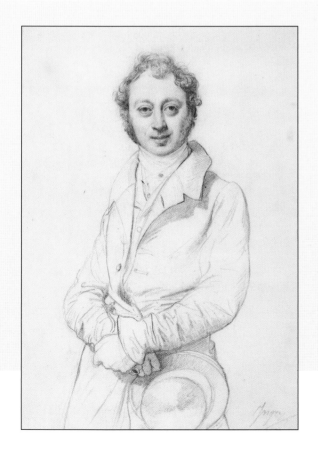

AUTHOR'S NOTE: As a young art student, I loved and admired the drawings of great Renaissance masters like Michelangelo, Raphael, and Leonardo da Vinci, as well as more modern master draftsmen like Degas, Daumier, Goya, and Ingres. Their art has inspired and educated me my whole working life as an artist. I've included historical notes throughout the book to give you some insight into how these artists employed the techniques I teach, and how timeless these lessons really are.

Jean Auguste Dominique Ingres,
The Archeologist Désiré-Raoul Rochette, c. 1830

ORGANIC ELLIPSES: Drawing Round Objects Like Fruit

When drawing rounded organic objects, which are often not perfectly symmetrical, we can still use plumb lines and ellipses as general guidelines.

Start with a geometric object of similar shape to the fruit or vegetable you're drawing. Lightly sketch the underlying geometric shape. Then, sketch the fruit or vegetable over the basic shape, using it as a guide. In the example below I drew a cylindrical shape that looks like a tire first, and then drew the apple on top of it.

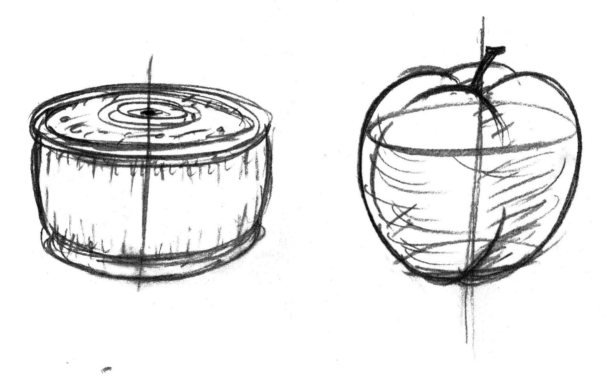

DRAWING TIP: Draw a tire shape just as you would a cup, but make the sides shorter and curve them out a little.

The drawing below uses the same principle. Because the apple is sitting on its side, I first drew a plumb line at an angle. **The plumb line should always run straight through the apple's core, like its stem.** This is the apple's central axis. I then drew a tire shape around the plumb line, using the rules we've gone over previously for cylindrical shapes. Finally, I used the tire shape as a guide for drawing the apple.

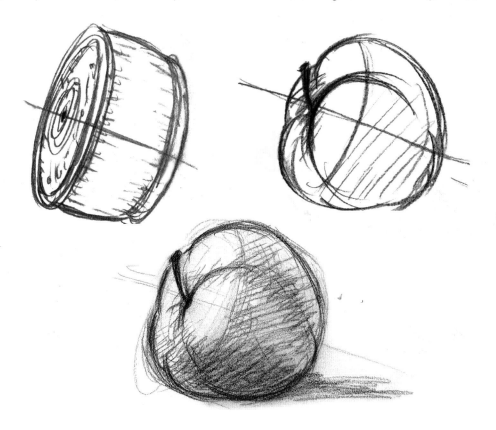

EXERCISE: Drawing an apple

Follow the steps to copy the drawing of an apple lying on its side.

1. Lightly draw a plumb line representing the center of the apple.

2. Draw two secondary plumb lines at right angles to your main plumb line. These will tell you where to place the ellipses on the top and bottom of your tire shape.

3. Draw the top and bottom ellipses of your tire around your horizontal plumb lines.

4. Draw the sides of the tire. They should be slightly curved.

5. Starting at the point where the top secondary plumb line and the main plumb line intersect, draw the apple's stem.

6. Using the guidelines you've established, copy the finished drawing of the apple on top of the tire. Erase the tire and plumb lines if you wish, and darken the contours of the apple.

RULE #3: Objects that are closer to the viewer appear lower on the picture plane.*

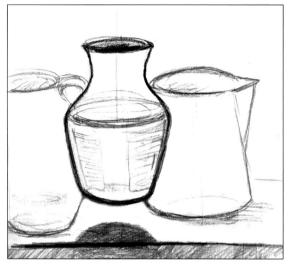

Incorrect

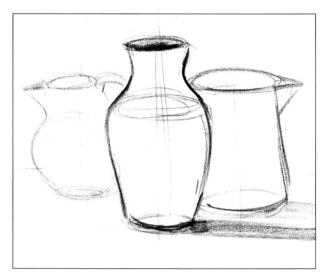

Correct

Why does the vase in the left-hand image look like it's floating in the air? Because it's higher on the picture plane than the objects behind it.´

The drawing on the right makes sense to your eye because the object in front is lowest on the picture plane, and the objects behind it are higher.

The farther away from the viewer an object is, the higher it will be on the picture plane.

DRAWING TIP: If at some point in the future you are drawing objects from an unusual perspective (looking up through a glass table, for instance), you may encounter exceptions to this. But you don't need to worry about that now.

A picture plane is the space in which you are drawing your picture—generally, a piece of paper.

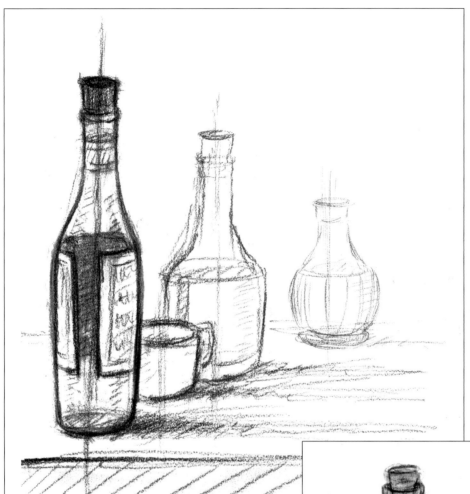

EXERCISE: Drawing a still life

It's best to do this exercise by setting up your own still life with three objects, but if you're not able to do so, work from a photo or copy one of the drawings in this section.

1. Following the previous lessons' rules (plumb lines, consistent ellipses, etc.), draw the object closest to you.

2. Draw the next closest object.

3. Draw the object that is farthest away.

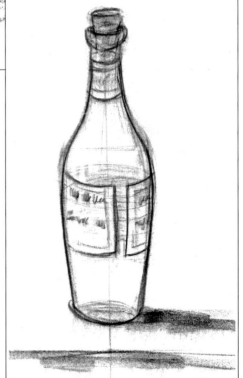

RULE #4: Dark lines come forward in space, and light lines recede.

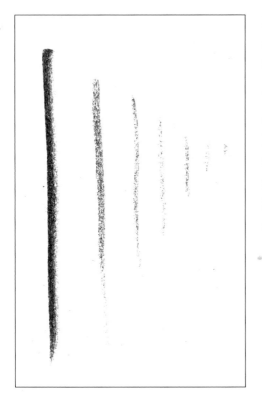

Look at the example on the left. The first line, which is darkest, appears closest to us as viewers. As the lines get lighter, they recede in space.

The finished illustration at right is an example of how dark lines come forward and light lines go back in space. Notice that the horse on the left appears closer to the viewer than the horse next to it. This effect is achieved not only by making the lines for the horse on the left darker but also by accentuating the dark lines where the horses overlap each other.

DRAWING TIP: The reason for this has to do with the way shapes and light/dark values become less distinct the farther away they are from your eye. Dark lines appear crisper and create more contrast between the color of the mark and the color of the paper, making them look closer to the viewer.

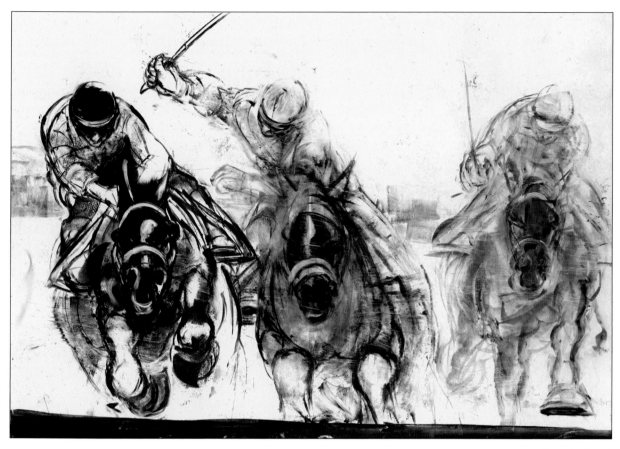

Down the Stretch

EXERCISE: Light and dark lines

Draw two objects, one closer to you than the other, using light and dark lines to accentuate the nearer object's closeness. It's best if you can set up two cups or bottles in front of you, but if you can't, copy cups or bottles from the drawings in the chapter or from a photo.

1. Using plumb lines and keeping your ellipses consistent, very lightly sketch the two objects. Make sure the farther object is higher on the picture plane.

2. Resolve your drawing of the closer object using dark lines. Hint: If you can see both sides of an ellipse, try making the closer edge of the ellipse a little darker, especially toward the middle.

3. Using lighter lines, resolve your drawing of the far object. Notice how the contrast between it and the darker-lined object enhances the feeling that it is farther away.

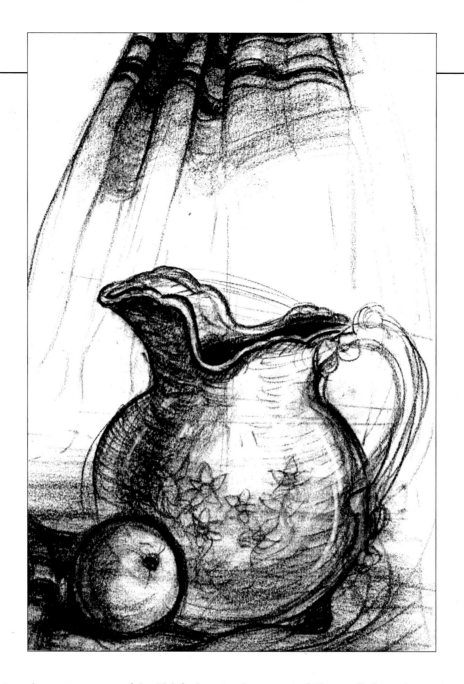

The illustration above is a successful still life drawing because it follows all the rules we've covered. I've used vertical and horizontal plumb lines on both the pitcher and apple, kept the objects that are closest to you lowest on the picture plane, and drawn nearer objects with darker lines. Now that you've gotten the hang of the four rules, try them out all at once on a new still life!

CHAPTER 2
LIGHT AND SHADOW

In this chapter, you'll learn to use light and shadow to define the shape of the objects you draw, creating an illusion of volume and weight. Light and shadow can also push things forward and backward in space, and are essential to making your artwork feel real.

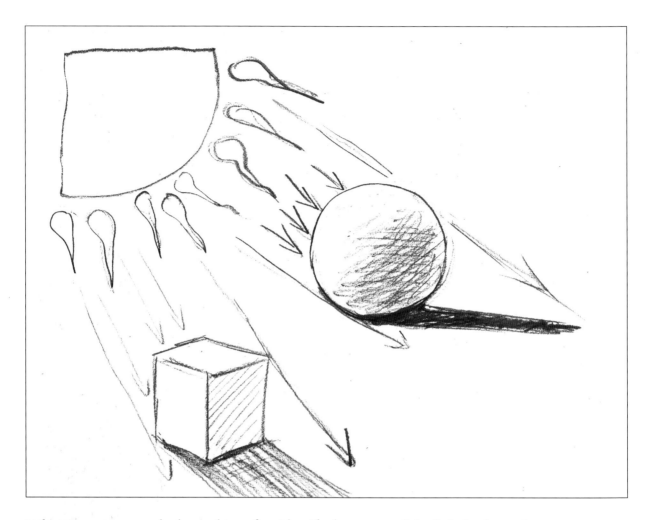

When you set out to shade an object, first identify the **source of the light** in the environment you are drawing.* This will tell you which parts of the object appear **lighter** (the parts the light hits), which parts appear **darker** (the parts the light doesn't hit, or hits indirectly), and **where the object's shadow falls** (typically, opposite where the light hits the object most strongly). If you're drawing multiple objects, keep the angle of their shadows consistent.

DRAWING TIP: If you're drawing an outdoor scene in daylight, the light source in your drawing is generally the sun. Establish the position of the sun in order to determine the angle and length of the shadows. As the sun sets, shadows grow longer. At midday, when the sun is directly above your drawing's subjects, shadows should be fairly short.

*Many environments contain more than one light source. For now, we'll focus on objects lit by a single, strong source.

SHADING SIMPLE OBJECTS

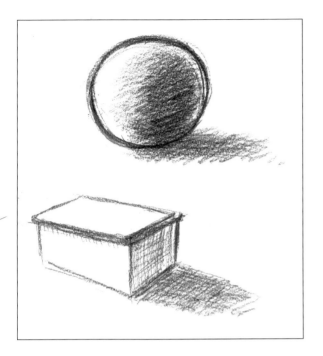

Take a look at the drawing to the left. From the placement of the shadows, you can tell that the light source is above and left of the objects. The parts of the ball and box that are facing the light source are lighter, and the parts that aren't facing the light source are darker. The part facing directly away from the light source is darkest. Each object's shadow falls behind the darkest part of the object.

These same principles are used to shade the tire, and then the apple, in the illustration to the right.

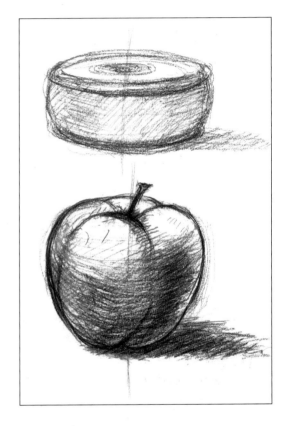

EXERCISE: Shading a sphere

1. Draw a circle.

2. Imagine that the source of light is **above** and to the **right** of the sphere.

3. Using the illustrations above as reference if needed, darken the part of the sphere that would be in shadow. **Hint:** On the dark side of the sphere, leave a little light around the very edge, except on the bottom of the sphere. This will help the sphere appear round.

4. Add a shadow behind the sphere. Remember, the shadow should fall opposite the light source.

SEEING THE SHAPES OF SHADOWS

The complexity of the shadows on and around objects can initially seem overwhelming. You may find it helpful to **squint**. This filters out many of the subtle shadows and tones, making it easier to break objects up into **large areas of dark and light**.

When you first add shadow, don't worry about details—think of everything in your drawing as either dark or bright, and shade the dark areas. You can fill them in lightly and decide later how dark to make them, or make them very dark right away and use an eraser to lighten parts of them as you add detail to your drawing.

AUTHOR'S NOTE: I usually start by blocking dark areas in with **soft charcoal**, and then use a **kneaded eraser** to pull out the half-lights and subtle tones.* For an example of this method, take a look at the illustrations of the pitcher and orange below. In the first drawing, I've sketched these objects in high-contrast black and white. In the second drawing, I've rubbed away some of the charcoal with a kneaded eraser to create subtle gray tones.

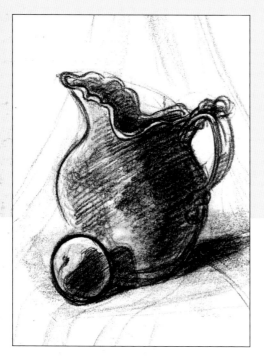 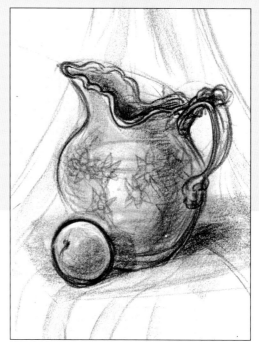

Take a look at the orange in either drawing—you'll notice that the shadow it casts moves vertically up the side of the pitcher.
If the shadow of an object falls on another object, the object on which the shadow falls will alter the shape of the shadow.

*See the Materials section on p. 8.

EXERCISE: Shading a still life

Set up a still life with two or three simple objects, such as cups and bottles.** You can also work from a photo. If you have no objects or photos at hand, copy the drawing of the pitcher and orange on the previous page.

1. Identify where the light is coming from in your still life.

2. Squint so that the shapes of the dark and light areas are more clearly defined.

3. Lightly sketch the outlines of the shadowy areas. Make sure all of the shadows cast by the objects fall at the same angle!

4. Fill in the shadows with a soft dark pencil (**2B** or softer*). If you don't have a soft pencil, shade lightly, as harder pencils can be more difficult to erase.

5. Look at the objects again. Try to spot where the shadows aren't quite as dark, and where there may be areas of subtle shadow in the lit portions of your still life.

6. Using your kneaded eraser (or a regular eraser if you don't have one), press on the dark areas you want to lighten. Pressing harder will lift up more of the graphite, and rubbing with the eraser will lift up more still. You can also use the eraser to blend and soften your shading. Hint: Try pinching your kneaded eraser into a fine point to remove or soften very small areas of shading.

7. Use your pencil to add in any details you left out of your original sketch, or that got unintentionally smudged as you refined your shading.

***If you have a lamp or flashlight at hand, shine it on one side of your still life to create more dramatic, defined areas of light and dark.*

SHADOWS AND REFLECTIONS

Shadows don't generally have hard edges, even if they are dark shadows. But reflections often do, whether they appear in glass, on water, or on another reflective surface.

If you are drawing a bottle that is sitting on a wooden table, the bottle's shadow should have a soft edge, even if it is a dark shadow. But if the bottle is sitting on a glass table, and you are drawing its reflection, the edges of the reflected image should be hard and crisp. If you give your shadows hard edges, you may make them look like reflections on a shiny surface instead.

Shadow is also crucial to landscape drawing and architecture. It heightens a drawing's sense of drama, dimension, and most importantly, deep space. For more on landscape and architectural shading, see Chapters 6 through 9.

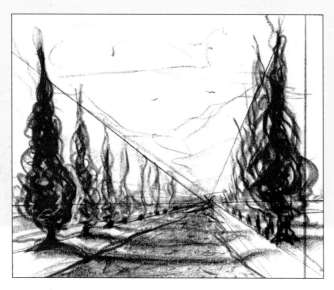
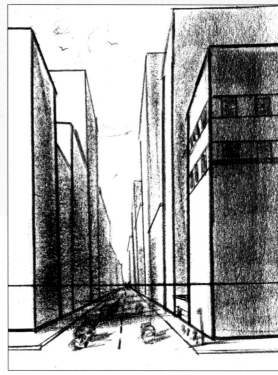

EXERCISE: Drawing areas of light

Using the reverse-shading method detailed below, draw a simple object, such as a cup or piece of fruit, from life. If you can't draw from life, use a photo or copy a drawing in this chapter.

1. Darken the whole page with a pencil. This will work best with a soft pencil, such as **2B**.

2. Squint at your still life, and instead of looking for the shapes of the shadows, look just for the shapes of the areas of light.

3. Using a kneaded eraser, or a regular eraser if you don't have one, try to draw the object by erasing *only* **the shapes of the areas of light**. Don't worry about the outline of the object; just erase where the light hits it most strongly. To make thin lines of light in the shadow, pinch the kneaded eraser into a fine point.

4. Add more subtle shading by rubbing or patting away the graphite gently with your eraser. If you wish, pick up your pencil again and add shading back in where you didn't mean to remove it, or draw in details you can't re-create with just an eraser. **Hint:** Don't worry if this drawing doesn't look neat, or quite how you expected. The purpose of this exercise is to learn to draw the shapes of shadow and light.

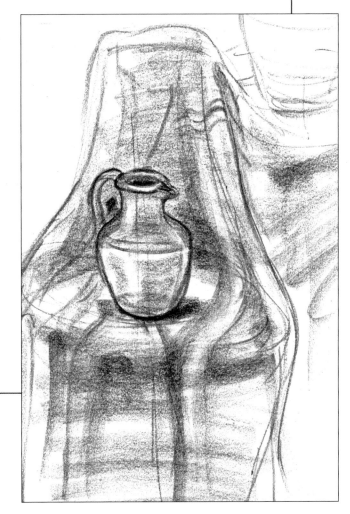

HISTORICAL NOTE: How an artist uses shadow profoundly impacts the mood of a piece. High-contrast shading can render a simple image intense, beautiful, and compelling. For examples of striking shadow, look at the works of Baroque painters like Caravaggio, Velázquez, Rubens, Vermeer, and Artemisia Gentileschi. These painters used a high-contrast style called *chiaroscuro* ("light-dark") to create powerful works. Some employed a more specific approach, tenebrism, in which a single strong light source illuminates an otherwise darkened scene. (You may have tried something similar when doing the exercises for this chapter, if you were able to set up a lamp beside a still life as suggested.) Artists can utilize such focused lighting to communicate tension and emotion.

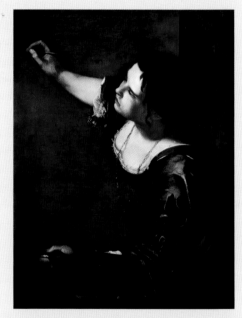

In the painting to the right, Gentileschi depicts herself with paintbrush in hand. The scene isn't inherently dramatic, but she uses strong light-dark contrast to imbue it with high drama. The viewer gets the sense that she is utterly absorbed in her painting. Through light and shadow, Gentileschi conveys the feeling of being passionately involved in a piece of artwork. Once you grow practiced at drawing, you will probably relate!

Artemisia Gentileschi, *Self-Portrait as the Allegory of Painting*, 1638–1639

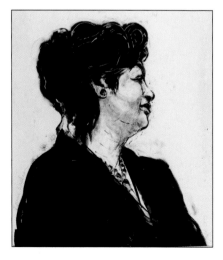

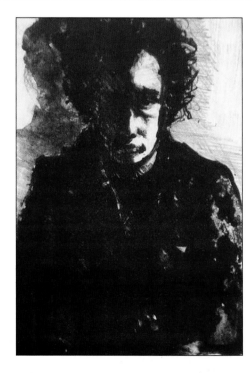

These images of mine use strong light and shadow to evoke a mood. I learned how to create this effect from studying great classical masterpieces like the example printed above.

CHAPTER 3
COMPOSITION

Composition *is the word used to describe the arrangement of objects in a picture plane.*

In this chapter, you'll learn some basic truths about composition, and find helpful guides for successfully placing objects in the picture plane. Four general guidelines for crafting an interesting composition are listed below:

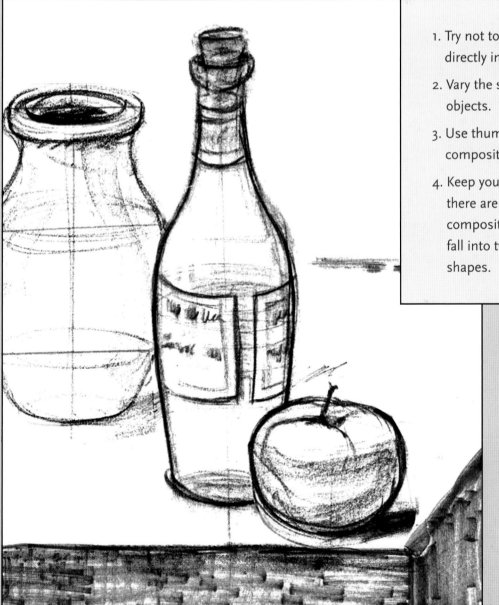

1. Try not to place your image or images directly in the center of the picture plane.

2. Vary the sizes, shapes, and spacing of objects.

3. Use thumbnail sketches to develop your compositions.

4. Keep your compositions simple. Even if there are many objects in a complex composition, break it down so that they fall into two or three large dark and light shapes.

PLACING YOUR OBJECTS

When learning to develop good compositions, **think simply**. Work with just two or three basic shapes or objects. Compositions can be static and uninteresting if objects are all approximately the same size and shape, placed at equal distance from each other, or positioned in the center of the page. By varying sizes, shapes, and/or the spacing of the objects, you can make the composition much more vibrant.

Try not to place your objects directly in the center of your sketch page unless you have a reason for doing so. Dropping an object in the middle of the picture plane creates a static, motionless composition. Even if the object is beautifully drawn, its beauty may be diminished if your composition is not dynamic.

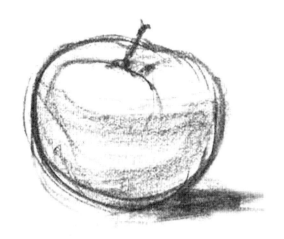

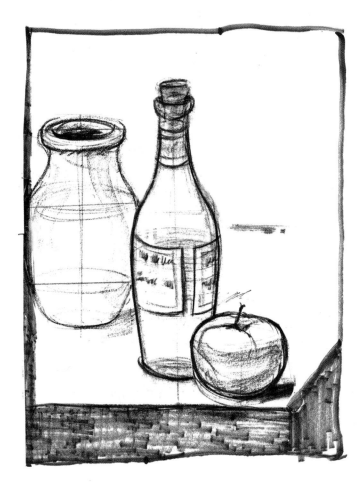

One way of making a composition more dynamic is to partially cut one or more objects off at the edge of the picture plane. This can bring a close-in view and a feeling of intimacy to the drawing.

It can also be useful to overlap two or more objects, and place them off to one side of the picture plane. This will create visual tension by varying the amount of negative space on each side of the objects.

NEGATIVE SPACE

Negative space is comprised of the open, empty areas of the picture plane that fall around drawn objects.

It may seem strange to think of empty space as important, but the way you handle negative space can make your drawings seem static or dynamic, flat or dimensional. It can give them mood and tension.

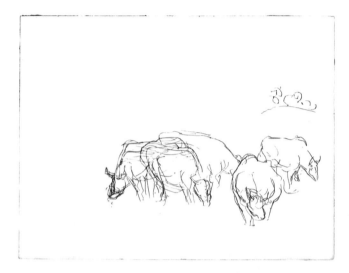

In this drawing, the cows are clustered in the bottom right corner of the page. There's only a little empty space below and to the right of them, and in contrast, the space above and to the left of them seems vast. The imbalance creates tension, and adds life to the drawing.

Here, three apples are viewed from the same angle, are the same size, and are placed at the same distance from each other in the center of the page. This composition is static and flat.

AUTHOR'S NOTE: I tell my students that a beautifully drawn object or figure placed in an uninteresting or confusing composition is like a very handsome person in clothes that don't fit.

EXERCISE: Create a dynamic composition

1. Consider a few ways in which you might improve the composition of the above drawing of apples. You might, for example, move two of them closer together, or place one of the apples nearer to the viewer.

2. Working from the drawing, quickly sketch the apples in a more dynamic, interesting composition. If it's helpful, use the underlying-tire method from Chapter 1 (page 9) to draw them.

USING THUMBNAIL SKETCHES

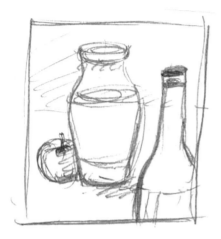 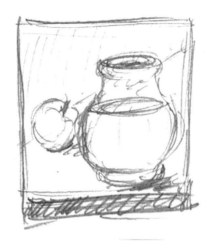

Thumbnail sketches can help you develop more interesting compositions.

A **thumbnail sketch** is a small, fast experimental sketch. (The term originally referred to a literally thumbnail-sized image, but these days most people's thumbnail sketches are two to three inches square.) Artists often create thumbnail sketches before they begin their final drawing, to preview a few possible compositions for their piece. They then base their full-size drawing on the most interesting thumbnail.

If you're drawing a still life, try walking around the objects and creating thumbnail sketches of them from different angles. Sketch them from above and below. Zoom in on an object, so that it's very large in the foreground. Cut off an object at the edge of the picture plane. Have fun experimenting! Many artists dash off at least three thumbnails for every finished piece of artwork.

EXERCISE: Composing a still life

Arrange a still life containing two or three simple objects such as cups, bottles, and fruit. If you're not able to set up a still life, try working from a photo, or pick something you see near you to draw.

1. Draw a quick thumbnail sketch of the objects.

2. Either move so that you're viewing the objects from a different angle, or just imagine them placed differently in the picture plane. Draw another thumbnail sketch.

3. Change your perspective again, and do another thumbnail sketch. Repeat as many times as you like. Keep in mind the factors that make a composition interesting.

4. Don't take down your still life! You'll need it for the next drawing exercise, at the end of the chapter.

COMPLEX COMPOSITIONS: Keep It Simple

If you're drawing a complex, busy piece, it's easy to let your composition become muddled and confused. Avoid this by **breaking the image up into a few large areas of light and dark**.

Look at the rough sketch and final drawing below. Even though there are many individual buildings in the background of the picture, they seem at first to be part of a larger light shape. Despite the fact that the composition is made up of many parts, viewers will initially perceive just three or four dramatic dark and light areas. From the rough sketch, you can see that I planned this when I first worked out the drawing's composition.

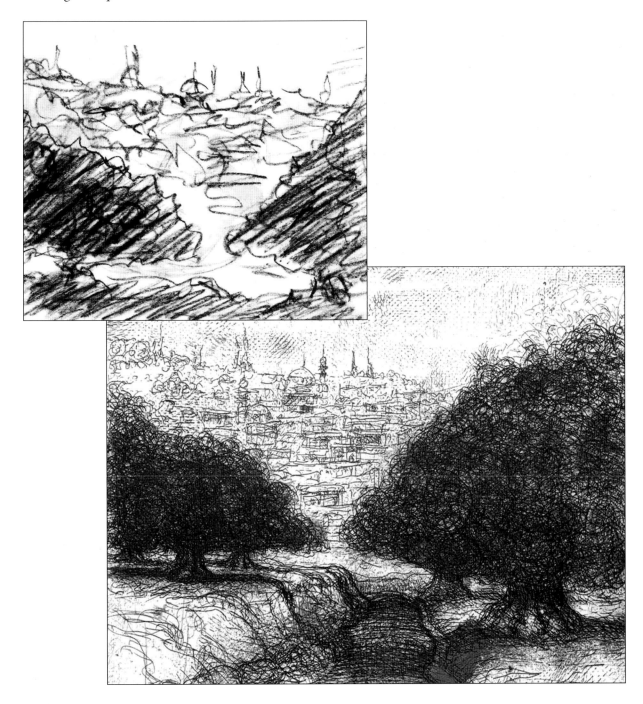

COMPOSITION AND MOOD

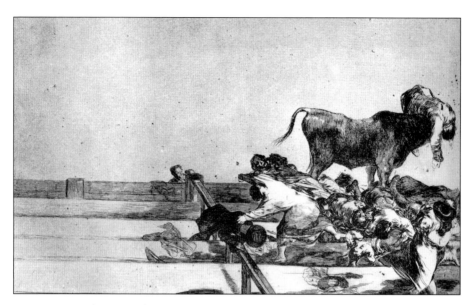

Francisco de Goya, *Unfortunate Events in the Front Seats of the Ring of Madrid*, c. 1815–1816

Composition can dramatically affect the mood of a piece.

I have always been enthralled by the above etching of Goya's from his bullfight series. It is a horrifying image: A bull has gotten into the bleachers and killed a spectator, and is walking away. The man's body is draped over the bull's head.

Notice how the bull—and the body draped over its head—create a kind of graphic shape similar to an arrow whose point comes very close to the edge of the picture plane without touching it. This causes visual tension, as the viewer's eye is crammed between the edge of the bull's head and the border of the picture plane. The rest of the composition is basically empty except for the lines representing the spectators' benches, which further guide your eyes into the very narrow space where this horrifying event is crystallized. The subject is disturbing enough on its own, but the composition intensifies its impact many times over.

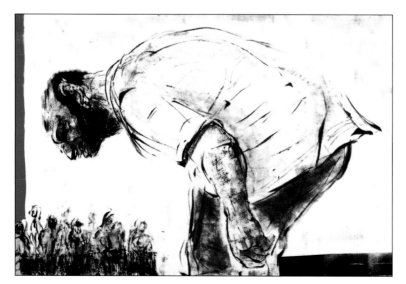

Goya's etching had a tremendous influence on me, and I wanted to use a similar composition for my piece, *The Giant*. I tried to create a dynamic graphic composition by forcing the viewer's eye up against the edge of the page and then stopping it with a vertical red strip. The image would have a different feeling without this visual tension.

The Giant

In the illustration above, I tried to create a powerful composition by breaking the picture plane into two high-contrast graphic shapes, one light and one dark. Your eye is pushed to the edges of the picture plane in this image also, and I ran the face of the man on the left off the picture plane to emphasize his plight.

When you find an illustration that gives you a heightened feeling of tension or calm, think about the ways that the composition amplifies that mood.

DRAWING TIP: In general, evenly distributed space in a composition creates a placid mood, while uneven space evokes movement or tension. When you draw a scene containing people, it's especially helpful to first do thumbnail sketches that experiment with different arrangements in the picture plane, so that the placement of the people reflects and enhances the emotions they are experiencing.

PUTTING IT ALL TOGETHER

Below, you can see how both the sketch and the finished illustration of Frankenstein's monster work with strong elements of composition. Note that the picture plane is broken into two large dark and light areas. Frankenstein's monster's body is cut off at the edges of the image, and positioned slightly off-center. There is more negative space to the left of him than to the right of him. These factors combine to create a dramatic image full of life.

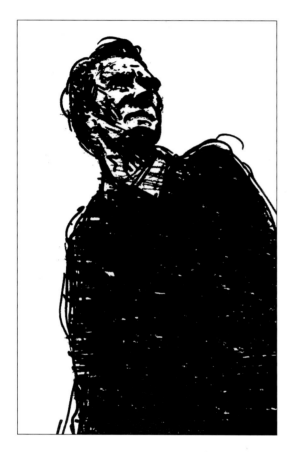 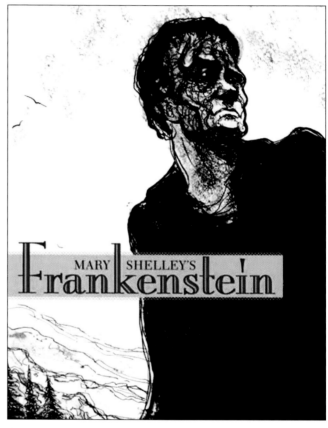

EXERCISE: Final still life composition

1. Look over your still life thumbnails from the previous exercise on p. 32, and choose one with a dynamic, interesting composition.

2. Do a full-page sketch of the objects based on your chosen thumbnail.

3. Look closely at the objects, and try to identify a few large areas of dark and light in your composition. Fill in large areas of shadow.

4. Finish your drawing, adding detail and more subtle shading.

CHAPTER 4
DRAWING CLOTH AND DRAPING FORMS

Unlike glassware or fruit, cloth has little solid structure of its own. The objects it drapes across or wraps around create and define its shape.

Drawing cloth is a great way to practice representing objects and materials that have no overall fixed form (like water and hair), but react in predictable ways to their environment.

HOW CLOTH WORKS

The most important thing to remember when drawing cloth is that it **takes its shape from how it's arranged, and the objects with which it comes in contact.**

The second major thing to keep in mind is that cloth is **soft**. Don't draw a lot of hard edges or corners on cloth, or it will look like driftwood instead of drapery. Some fabrics may crease sharply here and there. But overall, cloth forms soft and curving contours, especially if it is thick.

Cloth's third major attribute is what makes drawing fabric both difficult and enjoyable: **It folds**.

ON FOLDS

Folds are **peaks** and **valleys** in cloth. They extend from points of tension or directional change in the "flow" of the material. When something gathers, pushes, or pulls at cloth, it creates a fold.

In the drawing to the right, you can see that the very top of the cloth is draped over something narrow. This pulls the fabric up into a tapering point, creating folds whose lines start out sharply defined close to that point, and widen and soften farther away from it. Folds generally are narrower and/or more pronounced close to the point at which they originate, and spread out into soft curves farther away.

DRAWING TIP: It's not necessary to draw every little fold in cloth. Focus on the largest, which most effectively communicate the shape and movement of the material.

In the illustration to the right, a tabletop interrupts the downward flow of the cloth. Because the drapery is longer than the distance between the high point at which it is mounted and the tabletop, it buckles and folds in on itself. It twists and turns most noticeably right before it hits the tabletop, and as the lines of the cloth stretch upward and away from the table, they become smoother and more vertical.

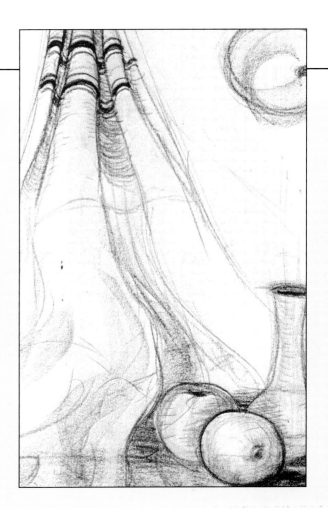

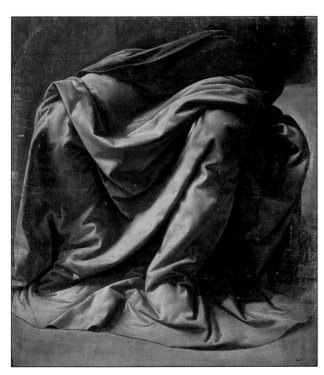

Leonardo da Vinci, *Drapery Study for a Seated Figure*, c. 1470

HISTORICAL NOTE: Leonardo da Vinci wrote in his notebooks about the gradual way that folds flatten and smooth out as they move away from their point of origin. In an essay titled "Of the Nature of the Folds in Drapery," he states of cloth that is bunched or gathered at a point, "...the part which is farthest from this constraint you will see relapses most into the natural state; that is to say lies free and flowing."

EXERCISE: Cloth, step by step

Using the steps below, draw a piece of cloth. If you're at home, try sketching a bunched-up dishtowel or item of clothing. Otherwise, follow along with the example drawing, copy another drawing from the chapter, or look at a photo.

1. Begin by loosely sketching the shape of the cloth and the lines of the major folds. Don't try to be scrupulously accurate, especially at first; concentrate on capturing the overall form the cloth takes.

2. Squint at the cloth, and look for the shapes of the major areas of shadow. Cloth, as mentioned, forms peaks and valleys when it folds; the peaks will generally be light, and the valleys will generally be dark. Focus on this when you add your initial shading.

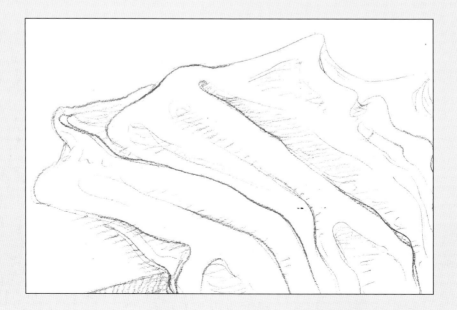

3. Refine your shading, darkening the regions of deepest shadow on and around the cloth, adding subtle grays, and further defining the shapes of your light and dark areas. Pencil in some narrow, very dark shadow in places right under the bottom of the material; this will give the cloth visual weight and volume.

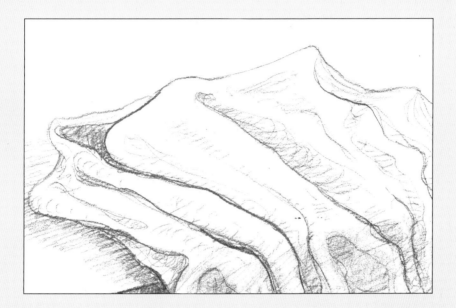

4. Finish adding detail to your drawing. If your cloth has a pattern or some decoration, draw it in now. Be sure that any patterning on your cloth distorts with the folds of the cloth. In the example, notice that the stripes curve over and under each fold, sometimes disappearing into the valleys in the fabric. This gives the material added dimensionality.

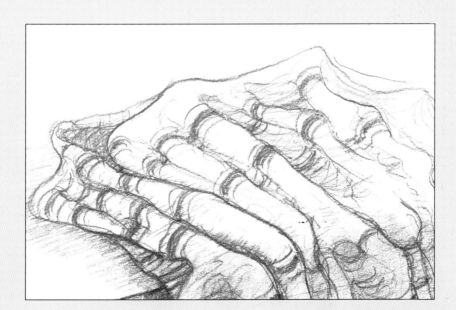

CLOTHING

The illustration of men in suits to the right is an example of how cloth can wrap around a human figure and take on its shape. The dark, angular suits also accentuate the drawing's uneasy atmosphere. Especially in drawings of people, cloth can create a mood in a piece, heightening its emotional impact and poignancy.

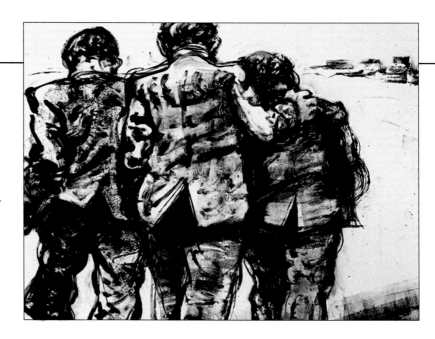

EXERCISE: Drapery in still life

Choose two or three simple objects (bottles, cups, fruit) and a piece of cloth. Drape the cloth across a table or other surface so that a little of it hangs over the table's edge, and arrange the objects around and on top of it. If you can't set up a still life, follow along with the drawing steps below.

 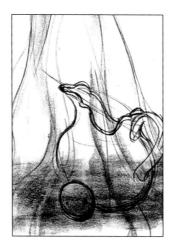 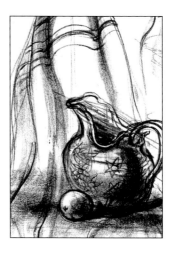

1. Look at the horizontal and vertical planes in your drawing. Is the horizontal plane (the tabletop) lighter or darker than the vertical planes (the space below the edge of the tabletop, and/or the wall behind the table)? Lightly shade the darker plane(s). This will give you a basis for your more detailed shading.

2. Sketch the objects and cloth, using what you learned in the last exercise to draw the fabric.

3. Roughly block in the shapes of shadows, with a soft dark (**2B** or softer) pencil if you have one. Soften and add subtle shades of gray to your drawing with an eraser, as you've done in other drawings. Finish your drawing by penciling in fine details.

CHAPTER 5
DRAWING WITH A "SPINE"

Many forms—from people to plants to animals to objects—contain a central line that describes their overall shape and movement. I refer to this line as the "spine." In people and most animals, the spine line is their literal spine; the line of the backbone dictates the positioning of the rest of the figure. In plants, the spine may be a stem or vein. In flattened, curving objects such as ribbons and mug handles, the spine often will be an edge of the object. It may help you to think of the spine as a plumb line for irregular shapes.

Learning to identify a spine line and use it to inform the rest of an image can lend your drawings movement and clarity. It will help you figure out how to render complex forms that turn in space, and open up a broad range of possibilities for your art.

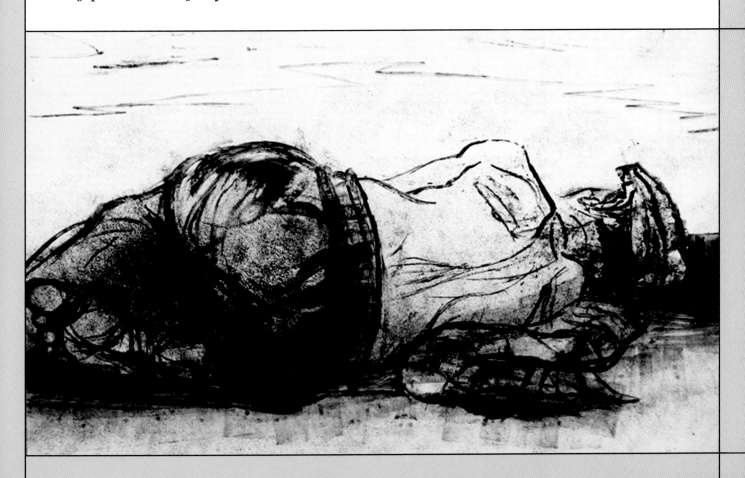

SPINES AND FLATTENED, BENDING SHAPES

Ribbons, flags, leaves, mug handles, and the Great Wall of China may seem unrelated, but they have one thing in common: they are all elongated, flattened, bending forms. Shapes of this kind are an excellent way to learn how to draw spines.

As these forms turn and undulate, alternating sides of them are exposed to the viewer. Between the wider, flatter sides of the object that come into and out of view are the thinner edges, the shapes of which indicate the path of the object's undulation. One edge is often most clearly and completely visible to the viewer; think of this edge as the object's spine. When you draw an elongated, flattened, bending form, begin by identifying and drawing the spine.

EXERCISE: Draw a ribbon

Using the breakdown below, draw a simple ribbon.

1. Begin sketching the ribbon by drawing the serpentine path of the ribbon's top edge, its spine. This will determine the shape of the ribbon.

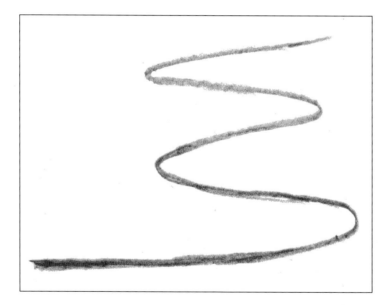

DRAWING TIP: Most objects of this kind have more than one potential spine (a ribbon, for example, has two long edges). Use the one that's most clearly visible to the viewer, as it will give you the most information about the object's overall form. In this case, we are looking at the ribbon from above, and so have drawn the top edge.

2. Next, use the path of the ribbon's spine to extrapolate the rest of its shape. The ribbon may narrow a little as it goes back in space, depending on your perspective; more on this in Chapter 6.

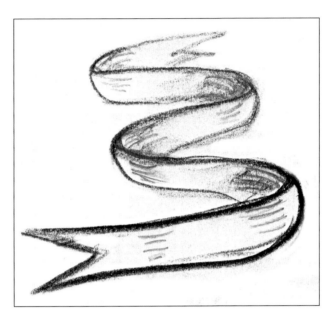

3. Lastly, add shading to the ribbon, to make it appear more three-dimensional. The insides of the U-shaped curves in the ribbon are likely to be darker, as it's more difficult for light to hit those areas directly. Note that some of the shading is conveyed by lines rather than soft dark patches, and that these lines follow the ribbon's twists and turns. This is a style choice that can enhance the dimensionality of the ribbon.

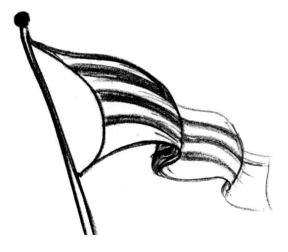

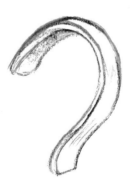

You can use this system for any kind of fabric that ripples, if you can see its edge. Here, I've used it to draw a flag. The flag's "spine" is the bottom edge, because the viewer is looking up at it.

The handles of mugs behave just like ribbons, curving around to show first their outside, then their inside, separated by an edge or lip. The curved edge facing the viewer—the spine—should be drawn first as a single line. If the edge is a little wider, you may want to depict it in your finished drawing as two close-together parallel lines, as I've done here.

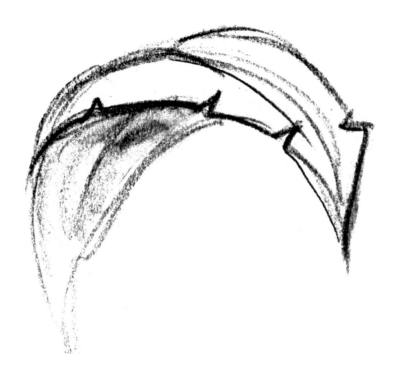

The basic structure of the leaf above is very similar to that of the ribbon, flag, and cup handle in that it bends around itself. Both its front and back side are made visible as it curves. There's one major difference, though: the spine.

Instead of the leaf's edge, the vein running down the center of the leaf is its spine. Draw it first as a continuous curving line. You may have to erase a little of the spine line later on, if part of it is obscured by the rest of the leaf.

DRAWING TIP: It may sometimes be the case that you can't see the entirety of an object's spine. Lightly sketch the whole spine anyway when you begin your drawing; you can always remove what you don't need afterward, and drawing the entire spine will help you determine how the object turns in space.

EXERCISE: Sketch a curved leaf

Follow the steps below to copy the leaf illustration. Then, try out the spine line method on a real leaf, or a photograph of one.

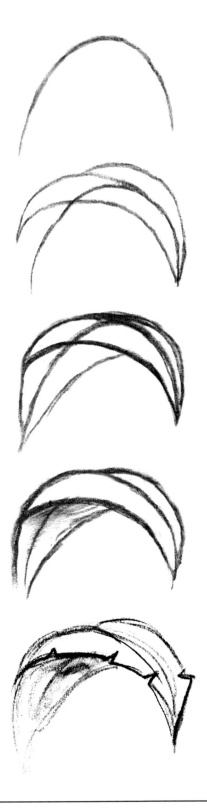

SPINES AND ANIMALS

The spine as a central guideline will prove useful to you over and over in the coming chapters, particularly those concentrating on organic forms. As you can see in the three-step dragon drawing below, I started the illustration with the curve of the spine, and arranged the dragon's form around it.

Like the ribbon and leaf, the dragon turns in space; the left-hand side of its head is closer to the viewer, but we see the right-hand side of its tail. Starting with a continuous curve representing the dragon's spine made it easier to draw this complex pose in a way that feels physically plausible.

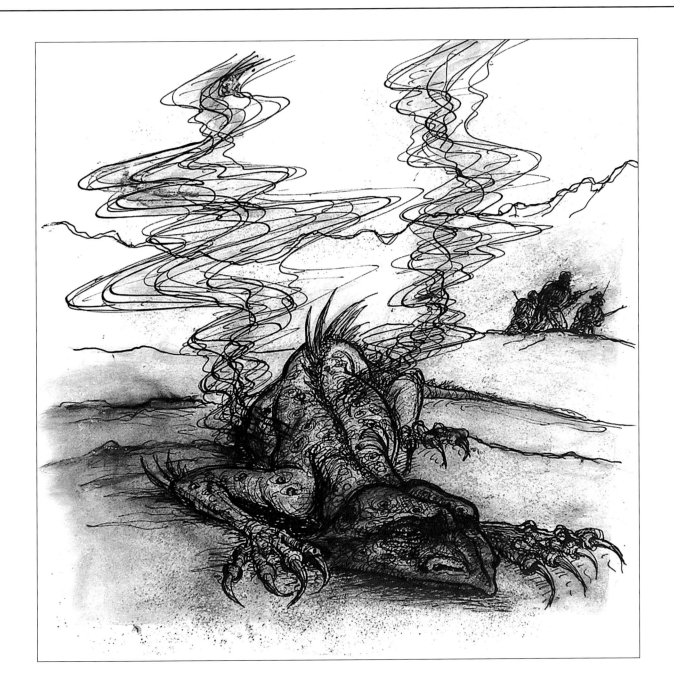

DRAWING TIP: Once you've drawn an animal or person's spine line, it's helpful to map the rest of the body out in large, simple shapes that follow the spine. We'll cover this further in Chapters 11 and 12. For more on drawing fantastical creatures, see Chapter 12, page 153.

SPINES AND ARCHITECTURE

You may find that architecture, too, is sometimes easier to draw when you use a spine line. One famous example of architecture with a spine is the Great Wall of China, which behaves somewhat like a thicker, more complex ribbon. It runs over mountains and in and out of sight, showing its left and right faces as it turns across the landscape.

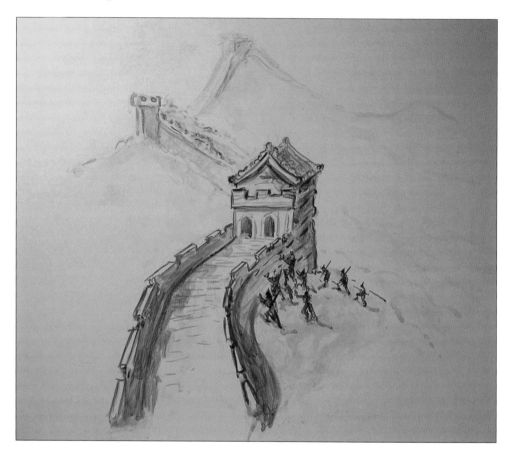

DRAWING TIP: I've combined several drawing techniques to make the twisting and turning of the Great Wall of China feel realistic. To enhance the sense that the wall extends far across the distant hills, I varied dark and light lines and tones (see Chapter 1, page 19). As the wall wraps back toward the horizon, the lines and tones get lighter and lighter until they almost disappear.

This effect is also helpful when drawing the ocean, especially on a foggy day. The waves that lap the shore have sharp tones and clear edges. As the ocean recedes toward the horizon, its tones and contours almost disappear, and the sky and sea blur until their textures are nearly indistinguishable.

CHAPTER 6
ONE-POINT PERSPECTIVE

Perspective drawing is a method of imitating how your eye perceives three-dimensional objects. Essentially, it will help you emulate on paper the way 3D forms shrink and distort as they recede in your view. You'll use perspective for everything from cityscapes and houses to landscapes and even, in some circumstances, the human figure.*

One-point perspective is the simplest kind of perspective.

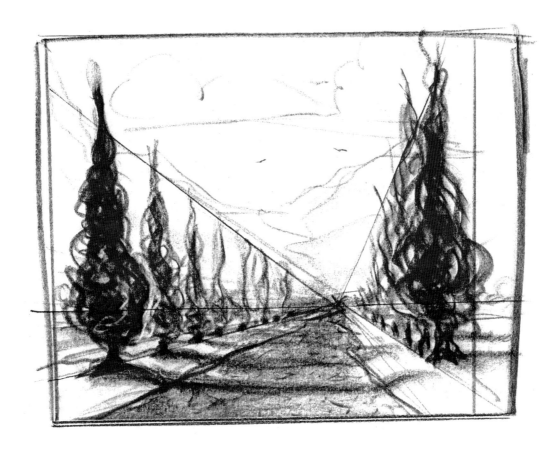

**As with many drawing methods and rules, perspective doesn't perfectly mimic the way your eye perceives space. Rather, it's a way of simplifying the complex things your brain intuitively understands about depth, and using them to create a clear system you can use for drawing.*

THE HORIZON AND THE VANISHING POINT

Perspective involves two kinds of major elements: **horizon lines** and **vanishing points.** Most perspective drawings start with a horizontal line that represents—you guessed it—**the horizon.**

Everything in your drawing vanishes toward this horizon, exactly as it does when you are, for example, looking out to sea. In real life, we often can't see the horizon. Other things are in the way. But it's there nonetheless, and its placement informs how we see everything else around us, so we draw it when we begin a perspective sketch.

Vanishing points are (at least in one- and two-point perspective) located on the horizon line. One-point perspective is so-called because it requires **one vanishing point**. Diagonal lines all over the drawing converge on this vanishing page.

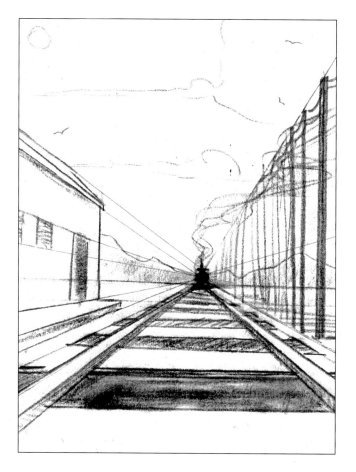

If you watched cartoons as a child, the image above might look familiar. You may have seen many similar scenes in which Bugs Bunny, Daffy Duck, or the Road Runner is tied up on the railroad tracks, with a train in the distance speeding toward him (and you, the viewer). It's a great example of one-point perspective and its dramatic potential in drawing. Notice how the horizon line (and therefore your perspective) is **low on the page**, to give you the sense that the oncoming train looms over you. Additionally, the vanishing point is centered on the horizon line. This may not be the best formula in general for an elegant and interesting composition, but in this case it emphasizes the feeling that the train is rushing straight at the viewer.

WHEN TO USE ONE-POINT PERSPECTIVE

One-point perspective works when you're drawing something while **facing one side of it directly** (or imagining that you are facing one side of it directly). If your subject matter is a building, for example, you might use one-point perspective if you (or an imaginary person whose viewpoint you are drawing) are standing parallel to one of its flat sides and looking straight ahead. If you are facing the building's corner, you might use **two-point perspective**, covered in Chapter 7. If you are facing the building's corner and looking up at it from an extreme angle, you might use **three-point perspective**, covered in Chapter 8.

DRAWING TIP: It's helpful to use a ruler or other straightedge for perspective drawings, especially if you are drawing buildings. If you don't have a straightedge, you can sketch your straight lines freehand—the ruler just makes drawing them easier and cleaner.

For quick sketches, it may be simpler to do without a ruler, and the organic lines of the natural landscape are often better suited to freehand drawing.

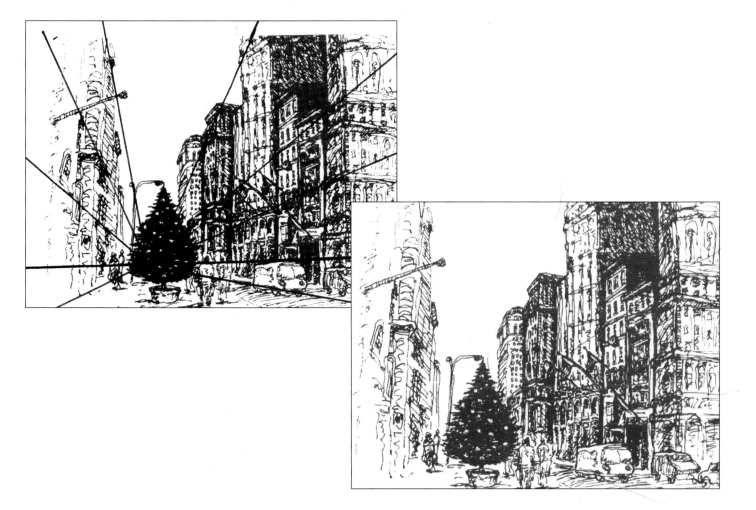

EXERCISE: A box in perspective

Perspective can help you draw all sorts of unbelievably complex objects. Let's start with a simple one for now: a box. It may be helpful to read through all the steps before you begin.

1. To create a drawing with one-point perspective, first establish the horizon line. Do this by drawing a straight horizontal line somewhere in the middle of the page.

 The horizon line is the eye level of the viewer. For the purposes of your drawing, imagine that your viewer is looking **up** at anything **above** your horizon line, and **down** at anything **below** it.

2. Now, establish the **vanishing point** somewhere on the horizon line. In one-point perspective, the vanishing point is the place **directly in front of the viewer's eyes**. Imagine that you are drawing this scene exactly as a pretend person just outside the picture plane sees it. The place on which that person's gaze is fixed is the vanishing point, and as everything else in the scene shrinks into the distance, it converges on that point.

DRAWING TIP: Think of the vanishing point this way—as the artist, you are the director of your own movie, and you can force the viewer to look at the scene you are drawing from any angle you want. This is an effective tool for creating different kinds of moods.

3. Start the box by drawing the **flat plane facing the viewer**. Because this plane is parallel to the viewer, it does not distort toward the vanishing point. It's a rectangle, with straight vertical and horizontal sides.

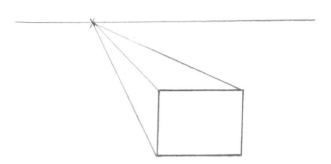

4. When you are looking at an opaque 3D rectangle, no matter where you are, you will only be able to see three sides of it at most. We've already drawn one side: the side facing the viewer. Look at where the box is in relation to the horizon line and vanishing point to determine which other sides you can see.

Because the box is below the horizon line, the viewer is looking down at it. Because it is to the right of the vanishing point, the viewer is to the left of it. **This tells you that the viewer should be able to see the top and the left-hand sides of the box from where she is standing.**

As I've done above, draw diagonal perspective lines connecting the bottom left corner, top left corner, and top right corner of the box's front-facing side to the vanishing point. This is what the sides of the box would look like if they were so long that they vanished into the horizon. That's a little longer than most boxes are, so let's make it shorter.

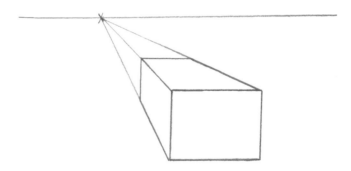

5. A short distance above the front top edge of the box, draw a horizontal line between the middle and right-most perspective lines. This is the far edge of the top of the box. Then, draw a vertical line connecting the left end of the horizontal line you just drew to the bottom left perspective line. This is the far edge of the left side of the box. You've now drawn all three visible sides of a box in perspective.

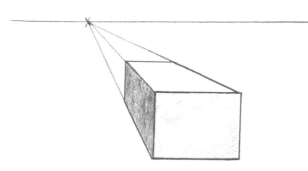

6. The box will look more three-dimensional if you add **shading**. In the drawing above, the imaginary light source is located above and to the right of the box. As a result, the top of the box receives direct light, the front side of the box receives indirect light, and the left side of the box receives very little light at all.

7. Lastly, erase the perspective lines that extend past the back of the box.

The horizon line as the eye level of the viewer works even when you are drawing objects from an unusual angle. In this drawing, we are looking at the buildings from above, and the horizon line and vanishing point are in the middle of the page because that is where the viewer's eye is fixed. Notice that because the building on the right-hand side of the vanishing point is located **on the horizon line**, we see **neither the top nor the bottom of it, but only its left side**.

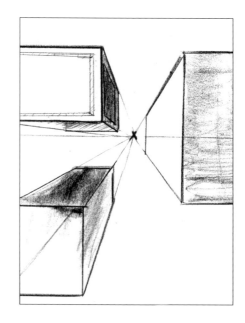

ONE-POINT PERSPECTIVE: Buildings and Cities

One-point perspective is critical for drawing architecture. Whether you're depicting a city scene or a single house, you'll need one-point perspective to give your drawing a feeling of deep and real space. In the two drawings below, perspective lines are integrated like a matrix underneath the cityscapes. They all converge on the single vanishing point, regardless of whether they are above or below the horizon line. If you look closely, you'll notice that in addition to determining major things like the angle of the buildings' roofs and foundations, and the relative size of the architecture as it vanishes into the distance, they determine smaller things like the relative size of the near and far cars on the road.

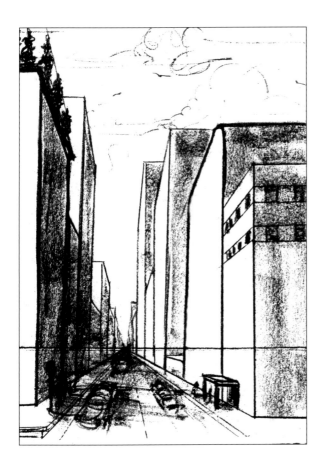 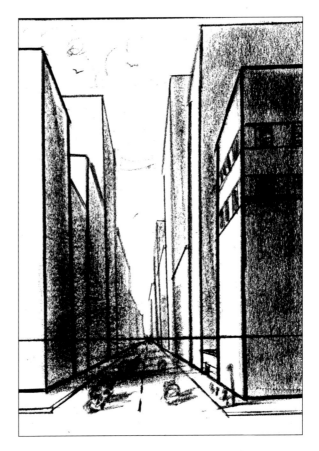

AUTHOR'S NOTE: Remember what I said earlier about thinking like the director of a movie framing a shot? There are lots of opportunities to change and enhance a cityscape by placing the horizon and vanishing point in different places. I situated the horizon lines in both drawings low on the picture plane, to give the viewer the feeling of gazing up at all those high-rise buildings. Then, I placed the vanishing points slightly to the side, to make the compositions more dynamic and interesting.

EXERCISE: Cityscape

Follow along with the drawings to create a city scene. A ruler or other straightedge may make this exercise easier.

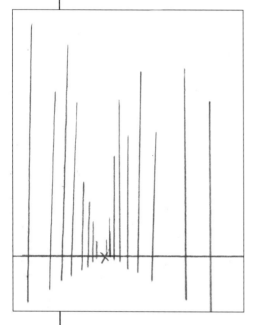

1. Draw your horizon line low on the page, and place your vanishing point on it, slightly to the left of center. Then, draw a series of vertical lines to each side of the vanishing point. They can vary a little in height, but in general should get shorter and higher on the page as they grow closer to the vanishing point. (The bottom of each line should always be below the horizon, though.) You can copy the number and placement of the lines I've drawn, or create your own arrangement, if you wish. As you draw and place the lines, keep in mind that these will be the sides of buildings.

2. Draw a perspective line connecting the vanishing point to the bottom of the right-most line. Do the same on the left. These lines represent the bottoms of the street-facing sides of the buildings. Erase any parts of the vertical lines that extend below them.

Then, draw horizontal lines connecting the right- and left-most vertical lines to the right and left edges of the page, respectively. These are the bottoms of the sides of the buildings facing you.

Next, draw the tops of the street-facing building sides. These will be at all different heights. Start by connecting the tops of the left- and right-most vertical lines to the vanishing point. Draw the line all the way to the vanishing point if you wish, or (this is much easier with a straightedge) stop when your perspective line hits the next vertical line, which is the side of the next building.

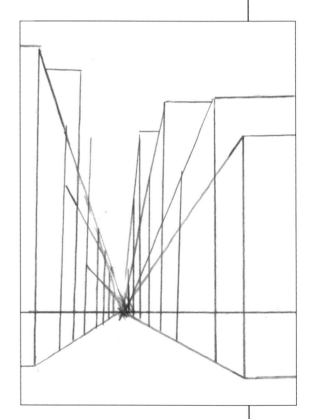

Draw the rest of the tops of the inward-facing sides of the buildings, starting at the outside and working in toward the vanishing point. Because the street-facing sides of the buildings are all aligned, perspective lines should connect each vertical line to the next

vertical line. If there's no upper perspective line between any adjacent pair of vertical lines, you're missing the top of a building!

Finally, draw a horizontal line from the outside corner of each building-front to the side of the next building (or perhaps, for a few buildings close to the viewer, the edge of the paper).

3. Erase any stray lines and clean up your drawing. Then, add basic shading. Imagine that the sun is **high above and to the left of the buildings**. This means that of the building sides we can see, the sun would hit the left-facing ones directly, the ones facing the viewer less directly, and the right-facing ones very little, if at all. Shade your buildings accordingly.

Begin to add a few major details, like sidewalks and perhaps an awning on one of the buildings. (You can also leave these out if you'd rather just focus on the architecture.)

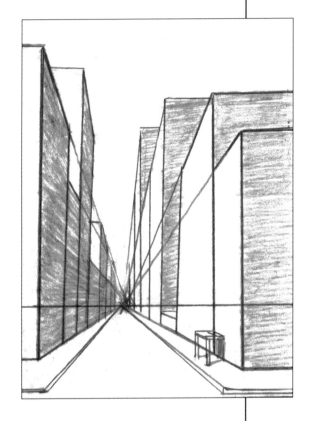

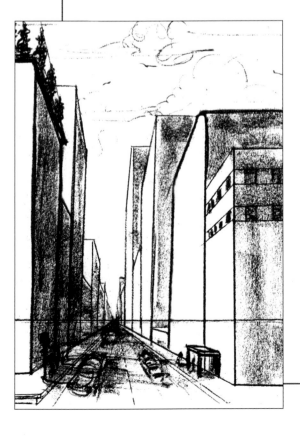

4. Use your pencil and eraser to blend and add subtle tones to your shading. Give the buildings on the left side of the street shadows, because the sun is behind them, and make them short shadows, because the sun is high in the sky. Then add details like cars on the street (using perspective lines to dictate their size as they recede into the distance), clouds, windows on one building, etc. Because your drawing depicts these things from farther away, you can just suggest their shapes with a few lines.

ONE-POINT PERSPECTIVE: Landscapes

Though they're composed of more free-flowing forms and fewer straight lines, one-point perspective can still bring landscape drawings to life by adding depth and realism. (For more on landscape drawings, see Chapter 9, page 83.)

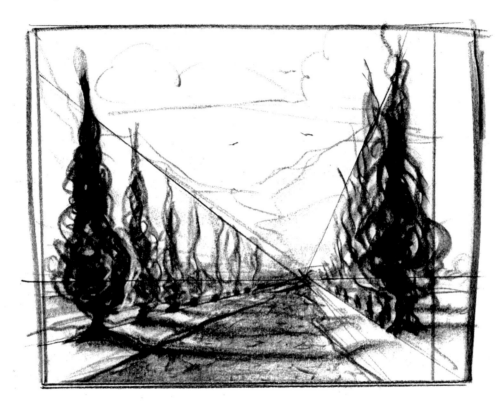

In the drawing above, the perspective lines dictate how quickly the trees shrink as they get farther away. Using perspective to determine the heights of the trees makes them recede into the distance realistically, giving the scene a feeling of depth. The tops of the trees don't conform precisely to a perspective line—nature is rarely that neat—but they follow it as a general guideline. The same is true of the edges of the path, which waver slightly as a real dirt path would but generally follow perspective lines to the vanishing point.

AUTHOR'S NOTE: A few years ago, a successful watercolor artist enrolled in my introductory drawing course at the Westchester Center for the Arts. Her watercolor landscapes were elegantly painted, but lacked a sense of depth. As a professional artist, she was reluctant at first to return to the basics, and resisted using the systems of perspective I taught in class. Once she began incorporating perspective into her paintings, however, she was amazed at how much dimensionality and realism it lent her work. She thanked me at the end of the semester!

VANISHING POINTS OUTSIDE A DRAWING

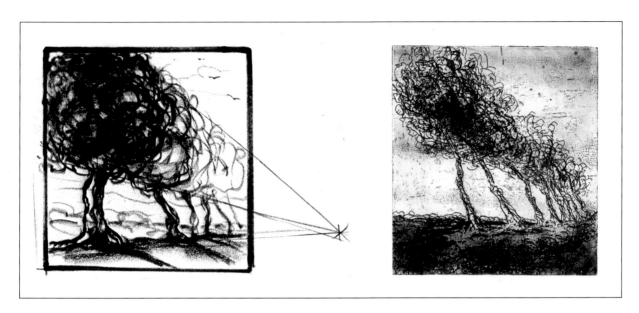

Sometimes the angle of a scene may require a vanishing point outside your drawing. There are a few ways around this, but the easiest is to **make your drawing smaller than your paper**. Before you begin, draw a rectangle inside your paper, leaving plenty of room on the side you'd like to place your vanishing point. The rectangle is now your picture plane, and you're free to draw vanishing points and perspective lines around it.

Perspective doesn't need to be obvious. The use of perspective is subtle in this drawing, but it provides an understructure that gives the scene a feeling of depth.

ONE-POINT PERSPECTIVE: Drawing Figures

We haven't covered people yet, but when you start drawing them, you'll find perspective very useful in depicting figures from unusual viewpoints. These sorts of angles create a striking larger-than-life feel, and can give a piece a strong mood. Alfred Hitchcock was famous for using extreme angles to dramatic effect in his movies. (For more on drawing people, see Chapter 11, p. 127)

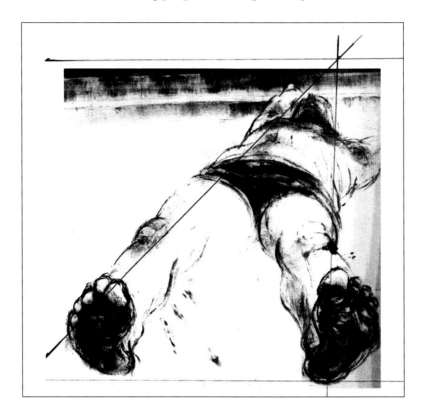

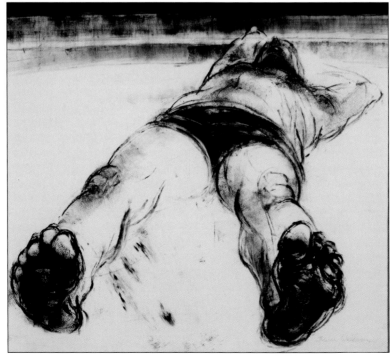

CHAPTER 7
TWO-POINT PERSPECTIVE

Two-point perspective works much like one-point perspective, except (as you may have guessed) for the number of vanishing points involved. It will help you make sense of complex angles, and allow you to draw the world around you from a broad variety of viewpoints.

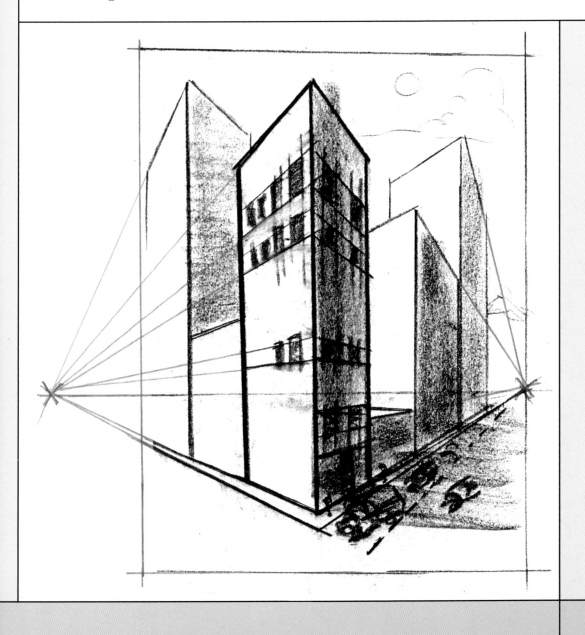

WHEN TO USE TWO-POINT PERSPECTIVE

In the simplest terms, you should use two-point perspective when you are (or the hypothetical person whose viewpoint you're drawing is) facing the **corner** of something.

Imagine standing on a street corner in a city, looking over at the corner of the opposite block. The buildings on the right side of the corner shrink to the right as they grow more distant; the buildings on the left side shrink to the left. You can't depict the two different directions with a single vanishing point. You need two points.

HOW TWO-POINT PERSPECTIVE WORKS

The **two vanishing points** in two-point perspective are located to the **far left and right sides of the picture plane.** Perspective lines converge on either the left or right point. As in one-point perspective, both points are located on the horizon line. But unlike in one-point perspective, they don't represent the viewer's gaze. Rather, the hypothetical viewer is looking somewhere between the two points. **The place on the horizon where the direction in which objects vanish switches from right to left—the corner—is where the viewer's eyes are fixed**.

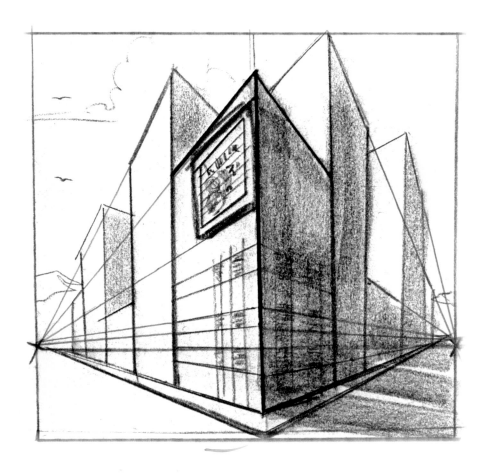

EXERCISE: A box in two-point perspective

Follow along with the drawings to depict a box in two-point perspective. A ruler or other straightedge may be helpful.

1. Begin by drawing your horizon line, keeping in mind that this will be the eye level of the viewer. Then, put in your two vanishing points, one on either side of the horizon line as shown in the drawing.

2. Now, draw a vertical line representing the front corner of the box. This is where your viewer's gaze is focused, and where the direction in which objects vanish changes.

3. Next, draw perspective lines running from the top and bottom of the corner line to the vanishing points, as shown above.

4. Pencil in the far ends of the box. Draw vertical lines that connect the upper and lower perspective lines on both the right and left sides of the corner.

5. Erase the parts of the horizon line that the box overlaps.

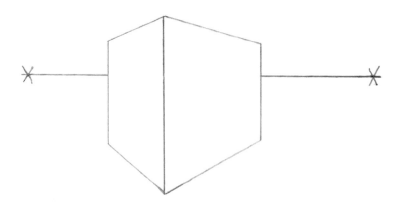

6. Erase the parts of your diagonal perspective lines that extend beyond the length of the box, and are no longer needed.

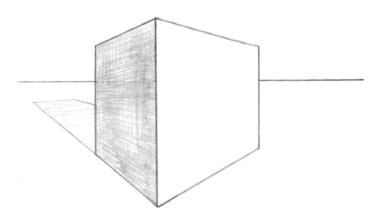

7. Shade your box as though there's a light source in front and to the right of it. This means that the shadow (because it's opposite the light source) will fall behind the box.

Shadows may not be tangible, but they're still visible shapes, and they recede in space like any other shape. Use perspective to determine the outline and placement of the shadow behind the box, and then fill it in.

Making sure your shadows are consistent with the rest of your drawing's perspective will enhance your piece's feeling of real and deep space.

DRAWING TIP: Remember that the location of the light source determines the shadow's length. A light source straight above an object creates a shorter shadow; a light source to the side of an object creates an elongated shadow. In this drawing, we're imagining that the light source is in front of the box, not directly above it, so the shadow will be longer. Below, it extends about half the height of the box.

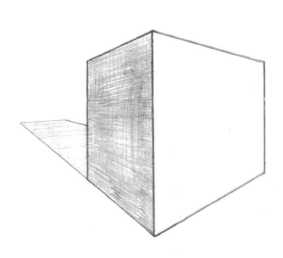

MOODS AND ANGLES

As with one-point perspective, you can use two-point perspective to draw images from a wide variety of angles. This includes scenes with flying or hovering objects, such as the floating block in the drawing below. Experiment with placing objects above, below, and on the horizon line. Perspective can affect the mood of a drawing, and it may be helpful to sketch a few thumbnails of a scene, to get a sense of how different viewpoints might alter its atmosphere.

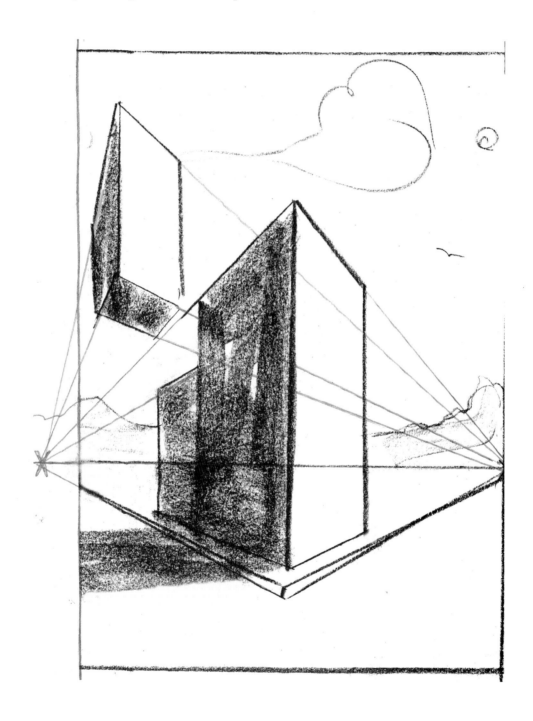

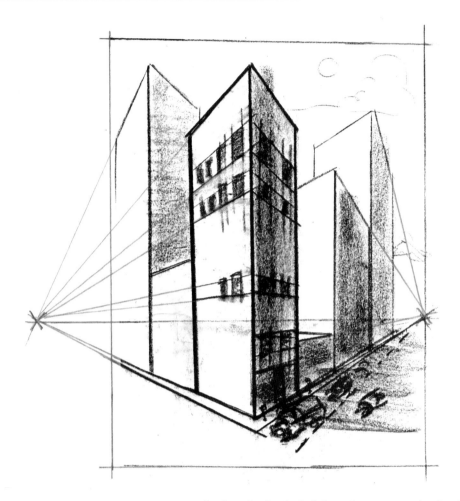

When using two-point perspective, you will often find it helpful to place **one or both of your vanishing points outside the picture plane**. Doing so will make the angles in your drawings less extreme, and is sometimes necessary in order to depict surroundings that recede from the viewer in a more subtle way. You can do this by drawing a smaller rectangle that represents your picture plane on your paper, and placing your vanishing points outside of it, as mentioned in Chapter 6. However, you may find that leaving ample room for vanishing points on both sides of your picture plane rectangle leaves you with a very small space in which to draw. In these cases, try using another piece (or pieces) of paper behind your drawing page. Tape the paper in place until you're done drawing.

DRAWING TIP: When your vanishing points are far away from the subject of your drawing, using a straightedge becomes key! It's harder to eyeball the angle of perspective lines at greater distances, and sketched lines may "wander" a little. Rely on your straightedge instead—it will make everything much easier.

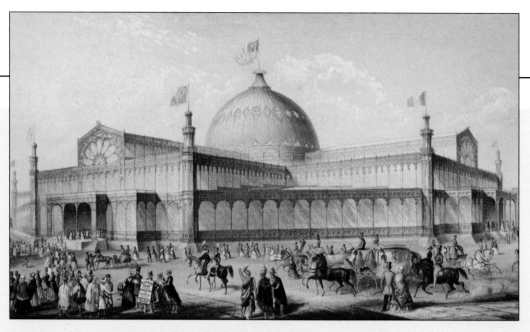

Karl Gildemeister, *New York Crystal Palace*, 1854

HISTORICAL NOTE: Architectural drawings throughout recent history have used subtle two-point perspective. The vanishing points are generally located far off the sides of the picture plane, creating understated angles. The result is a dynamic but not dramatic image that shows off two sides of the building illustrated, but doesn't distract from the architecture by portraying it at an extreme angle. Placing your vanishing points far off the page is a good way to depict complex viewpoints without creating a lot of visual tension.

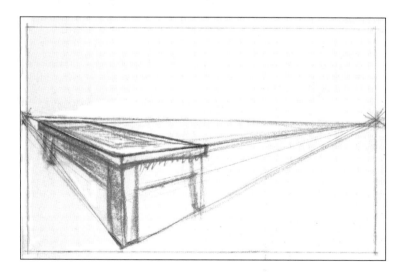

Perspective isn't just for large-scale scenes! It's equally useful in drawing smaller objects like furniture.

EXERCISE: Buildings in two-point perspective

1. Draw a low horizon line, and two vanishing points at the far edges of the picture plane. You can also draw them off the sides of the picture plane, if you like.

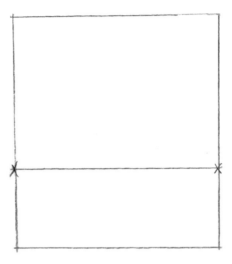

2. As you did with the box, draw a tall vertical line that crosses the horizon somewhere in the middle of the page. This is the corner of the building nearest the viewer.

 Then, draw perspective lines extending from both vanishing points to the bottom of the vertical line. These will be the bottoms of all of the buildings.

 Using the vanishing points, draw the remainder of the building's two visible sides with vertical and perspective lines.

 Once you've completed the first building, draw a few more vertical lines. These will be the edges of other buildings.

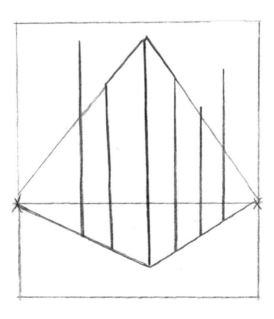

3. Complete the other buildings in the scene by connecting the vanishing points to the tops of the vertical lines, and adding more vertical lines to represent other sides of the buildings where necessary.

Then, shade the drawing as though the sun is above and on the left-hand side of the buildings.

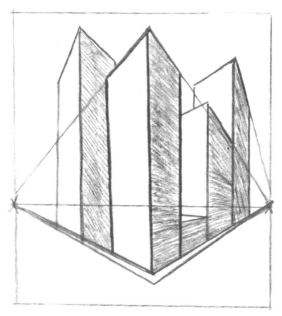

4. If you like, add details in perspective, such as windows, doors, cars, or tiny people. If you add cars or people, make sure to use perspective lines as size guides, so that they shrink believably as they get farther away.

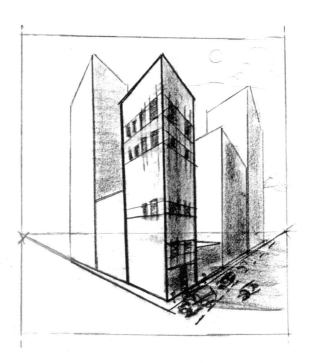

MIXING ARCHITECTURE AND LANDSCAPE

You've seen perspective drawings of both nature and architecture. Now we'll look at the two in combination. This may sound complex, but is in fact very simple. In essence, you just need to make sure everything in your drawing follows the same system of perspective.

The main difference between buildings and natural forms is that most buildings conform fairly precisely to perspective lines, while natural forms use them more as approximate size and direction guides. Use light perspective lines to map out the size and placement of everything in your drawing, and as you draw, use perspective to make sure the scale of everything makes sense.

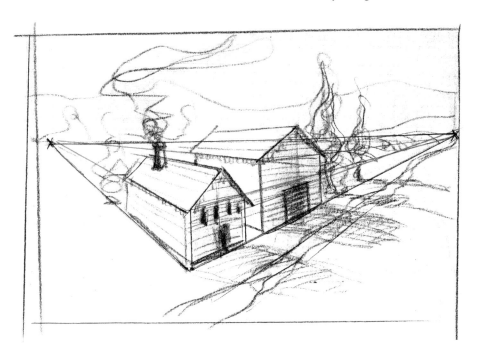

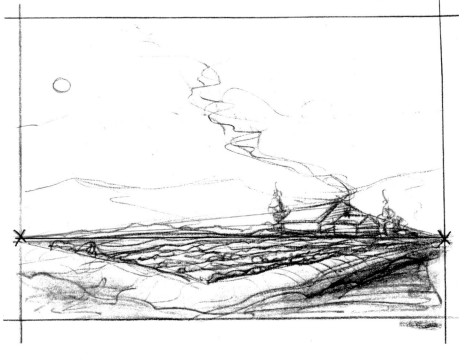

THUMBNAIL SKETCHES IN PERSPECTIVE

Once you've gotten the hang of perspective, you can quickly approximate it in **thumbnail sketches**. (For more on thumbnails, see Chapter 3, page 32.) You don't need perfectly straight lines to get a sense of how something will look in perspective, and when you're sketching at a small size, it's much easier to keep your perspective lines consistent without a straightedge. Use thumbnails to experiment with different placements of your horizon line and vanishing points, and see what viewpoint best matches the mood you want to convey.

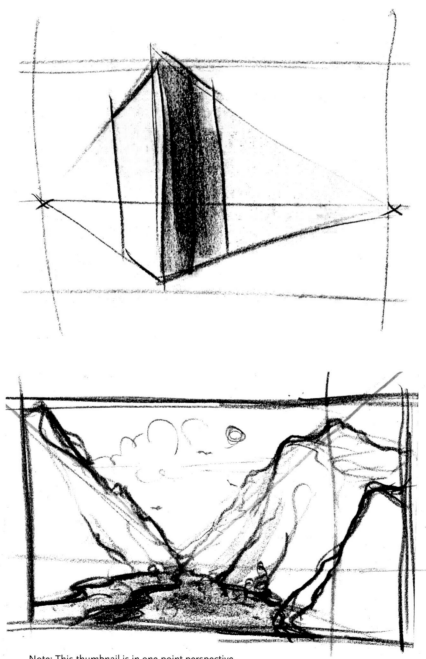

Note: This thumbnail is in one-point perspective.

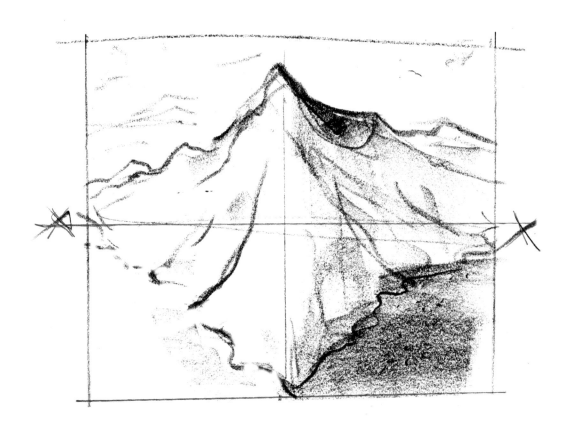

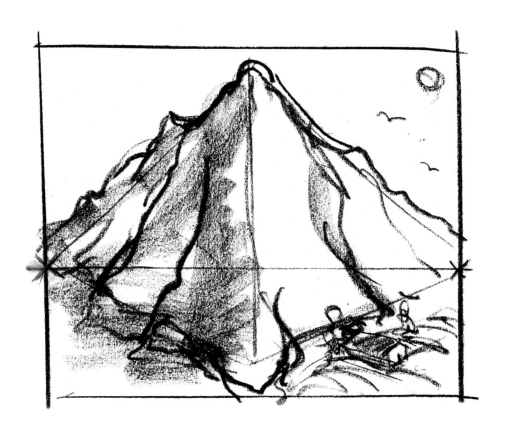

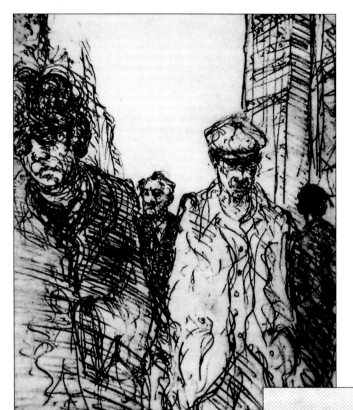

To the left is an etching I did a few years ago of Times Square during rush hour. To give the crowd a feeling of depth, the illustration uses two-point perspective to determine the heights of the distant figures. Two vanishing points sit off the sides of the picture plane, and the man in the cap—who is the focal point of the image—is the "corner." The heights of the two men behind him correspond roughly to the perspective guidelines. You can do this with crowds containing many more people.

CHAPTER 8
THREE-POINT PERSPECTIVE

Three-point perspective will allow you to create unusual and dramatic compositions. If you'd like to depict the viewpoint of someone gazing up at a very tall building, or looking down from a swooping helicopter, three-point perspective is your best bet.

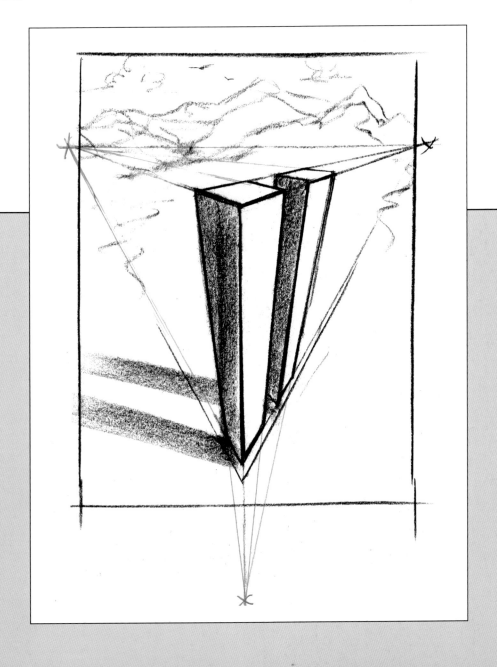

You'll probably use three-point perspective less often than one- and two-point perspective, but understanding it is no less important. In essence, three-point perspective lets you draw objects that vanish from the viewer in three different directions.

Let's go back to the swooping helicopter mentioned in the opening. Imagine that you're in it and it's circling a city block. As it rounds the corner of the block, it leans, and you look out. You see the tops of the buildings spreading out to the left and right, and below you, the sides of the buildings shrinking as they fall away, eventually meeting the sidewalk below. Because the things you see vanish as they get lower, as well as farther to the left and right, you need an extra vanishing point.

EXERCISE: Drawing a building in three-point perspective

1. Begin by drawing your horizon line.

Then, place two vanishing points to the far left and right of your horizon line, just as you would in two-point perspective.

Unlike your first two points, your third point won't be located on the horizon line. Its placement depends on whether you're drawing your scene from above or below. If the hypothetical viewer in your drawing would be looking down, place your vanishing point below the horizon. If the viewer would be looking up, the third vanishing point should be above the horizon.

In this exercise, you'll be drawing a building from above, so place your vanishing point far below the horizon.

2. Directly above your third vanishing point, draw a line representing the corner of the building below the viewer.

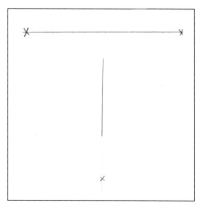

3. Draw diagonal perspective lines connecting the top and bottom of the corner line to both the left and right vanishing points.

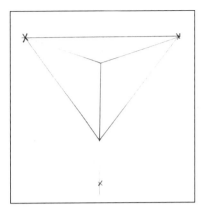

4. Establish the width of the building by drawing its sides. Start by drawing perspective lines that extend from the bottom vanishing point to the top lines you drew in the last step. Then, draw lines from the left and right vanishing points to the tops of the building's vertical sides.

Darken the parts of the lines that comprise the building. Then, shade the building as though the sun is low and to its left-hand side.

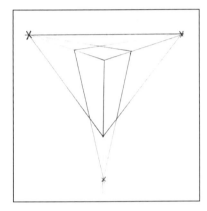

5. Erase all of the unnecessary guidelines. If you wish, add a shadow behind your building.

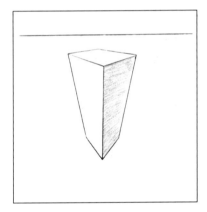

AUTHOR'S NOTE: This angle and composition was used very effectively in the movie *The Matrix,* when the protagonist, Neo, was being trained to jump from one high-rise building to another. The sequence was viewed partially from above, creating a sense of grand scale and drama. Drawing architecture from above for this chapter also reminded me in a sentimental way of some sketches I did in the past of the World Trade Center buildings.

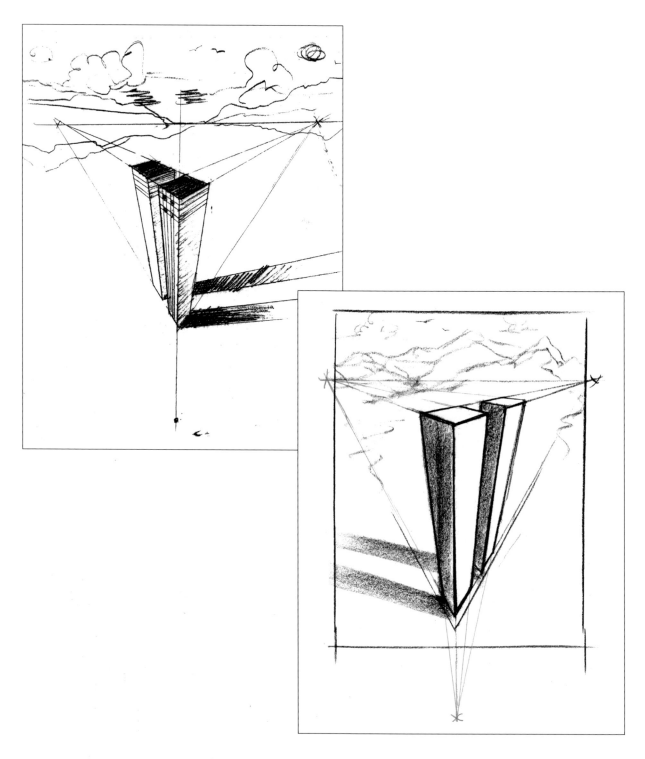

Three-point perspective can be a spectacular tool for conveying size in a drawing. The buildings above might not look quite as huge and impressive if drawn from one- or two-point perspective. Aside from accurately representing huge objects, emphasizing size difference can add tension, drama, and interest to a piece. In the illustrations above, the apparent height of the buildings and the fact that the viewer is looking down on them augments the sense that the viewer is very high up.

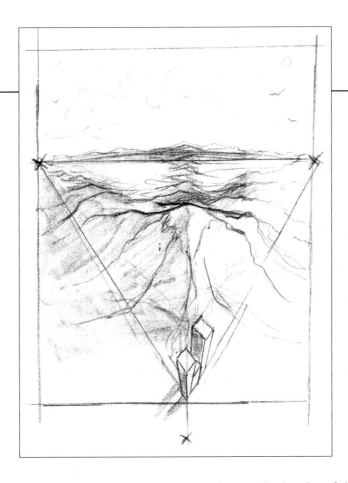

The drawing above uses three-point perspective to emphasize the height of the buildings as a way of indirectly conveying the scale of the landscape. The way the buildings recede toward the ground makes them appear very tall, but they simultaneously look tiny compared to the mountains. This contrast makes the mountains feel enormous and majestic.

The image to the right uses the same comparative size trick, but with objects that are smaller than the buildings. On the left, two parade floats glide down the street. Their size might not otherwise be clear, but the fact that they aren't tiny compared to the buildings makes it apparent that they are huge.

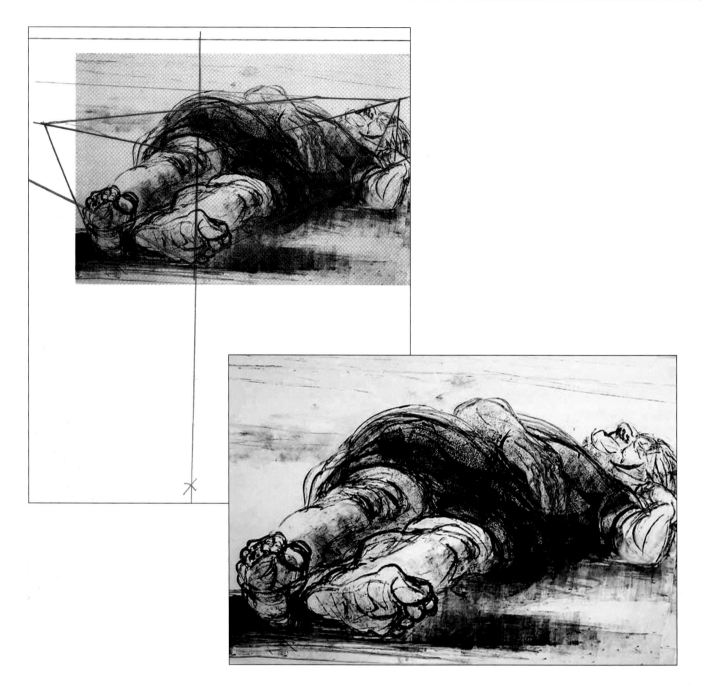

When you are drawing a person, and one part of their body is much nearer to the viewer than another, you may find three-point perspective very helpful in determining how this affects their proportions in your sketch. Approximate the overall shape and positioning of your subject's body with a geometric shape in perspective. Then, draw your figure inside this shape, using its dimensions as guidelines. For more on how geometric shapes can guide you as you draw people, see Chapters 10 and 11.

CHAPTER 9
THE LANDSCAPE AND THE LIVING LINE

Trees and plants are organic, living things.

Until this point, we've focused mainly on man-made, geometric objects like bottles and buildings. Plants are less predictable, less symmetrical, and frequently more complex. But despite the major differences between manufactured objects and living plants, you'll find many of the systems that helped you draw cups or city blocks will also help you depict the natural landscape.

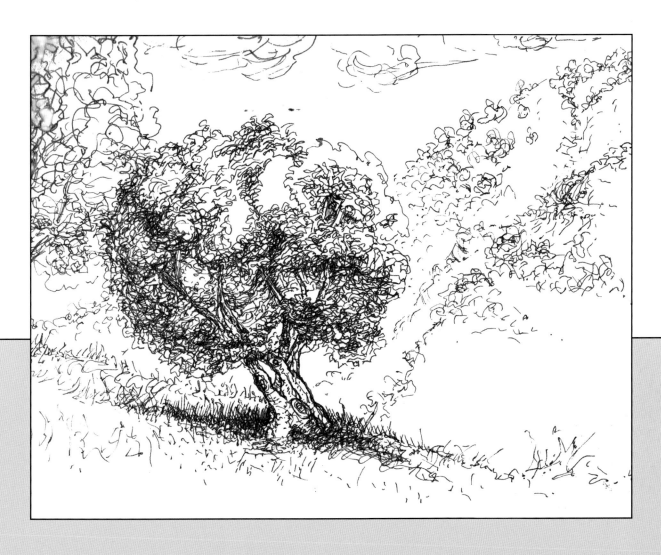

BENDING THE RULES

In previous chapters, you learned many rules that guided you in drawing realistic objects. You interpreted those rules somewhat strictly, as is the best course when drawing regular, predictable forms.

In this chapter, you'll start to use perspective, spine lines, ellipses, and other systems you've learned in a much more flexible and intuitive way. Chapters 6–8 touched on this briefly in demonstrating the usefulness of perspective when drawing irregular forms, from dirt paths to people. Now, you'll learn to follow a solid underlying visual structure with living line.

Living Line

I've always loved a particular quote from Daumier, the great 19th-century French illustrator. I like to share it with my students when they are learning to draw organic forms.

"I would take an inaccurate and incorrectly drawn living line any time over an accurate dead one."

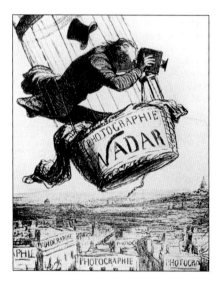

Honoré Daumier, *Nadar, élevant la photographie à la hauteur de l'Art*, 1869

So what is a living line?

A living line has a flow, a feeling of movement, and a variation of light and dark. It is loose and expressive, not tightly controlled.

You need confidence to draw with living line, and the best way to acquire that confidence is practice. As you draw, you'll learn to trust your impressions of your subject matter, and translate your intuitive understanding of shape into line with less and less hesitation. You'll find that a working knowledge of perspective and the other systems we've discussed will help you figure out the underlying structure of your landscape drawings, freeing you to focus on the dynamism and energy of your lines.

PLANTS, LEAVES, AND FLOWERS

In Chapter 5, you learned to draw a leaf, using its spine line as a guide. If you haven't practiced that exercise (on page 47) in a while, you may want to run through it again quickly now. It will help you with the exercises that follow.

EXERCISE: Flowers

Follow the steps to draw a flower, using a spine line and ellipses as guides. Then, if you like, repeat the exercise with a real flower or a photo of one!

1. Start with a line representing the flower's stem. This will govern the placement of everything else. (Think of it as the flower's spine.)

2. Using what you learned in the leaf tutorial on page 47, add a leaf to the base of the stem. Then, sketch the understructure for the flower's petals.

 Layered flower petals are often arranged in concentric rings. Draw a stack of ellipses that gradually grow smaller where you'd like to place your flower.

 After drawing the flower's understructure, widen the stem a little at the base of the flower.

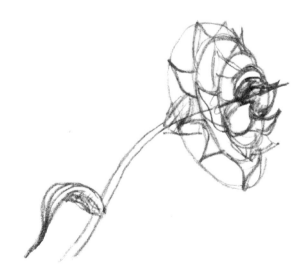

3. Using the stack of ellipses as a guide, draw the petals. Start at the flower's center and radiate out, making the petals just slightly larger toward the outside of the flower.

 When you're done, shade the leaf as you learned in Chapter 5.

4. Erase your guide ellipses and darken the lines of the flower's petals, particularly those on the side closest to you. Shade the underside of the stem, and add further details, if you like.

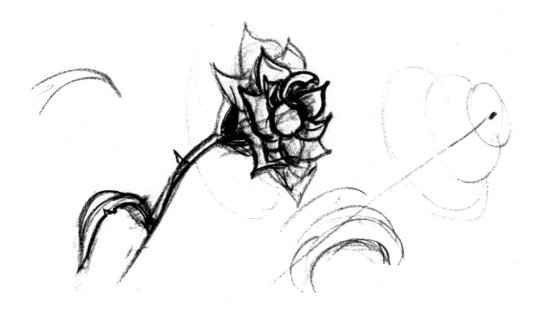

When you're drawing a flower from life or a photo, modify the steps a little to suit your subject. If the flower has only a single ring of petals, for example, draw only two ellipses—one for the outer edge of the petals and one for the center of the flower. Setting up an understructure for your drawing allows you to be bold when filling in the details!

TREES

Trees may seem complex, but if you know a few things about how they're formed, you'll be able to make perfect sense of them.

- The tree's trunk is its central axis—its plumb line or spine. All other branches extend from it. **Hint**: Sometimes the trunk will split partway up; in this case, draw the lines of both branches.

- Every part of a tree usually starts out wide and becomes narrower. This means that the base of the tree's trunk will be the widest part of the tree, and the place where each branch emerges from the trunk (or from another branch) will in general be the widest part of the branch.

- Tree trunks and branches may be knobbly and irregular, but are essentially shaped like tubes. If you're having trouble rendering them, it may be helpful to use the Slinky trick introduced in Chapter 1 (page 11).

- There are exceptions to this, but in general, trees grow upward. This means that overall, most trees' branches should be angled up toward the sun.

- Chapter 3 (page 29) discusses breaking detailed, complex compositions up into large areas of light and dark. This is one way of approaching large leafy areas. Instead of attempting to draw every leaf, try roughly drawing the texture of the leaves, making your lines denser and darker to indicate the shadowy parts of the foliage. Look at the above tree drawings for examples of this.

EXERCISE: Sketch a tree

Using the tips on page 88 to guide you, sketch a simple tree. Draw from life, from a photo, or copy one of the illustrations in this chapter.

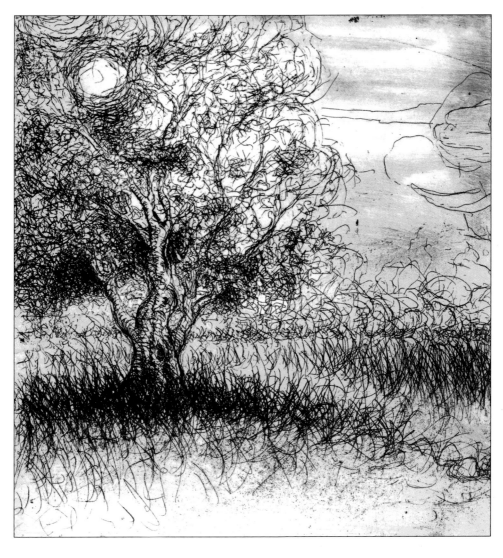

PERSPECTIVE

In previous chapters, we covered the uses of perspective in landscape drawings. (See pages 60, 73, and 81.) You can use it to make a field or forest recede believably into the distance, or a tree appear very tall.

Setting up and following perspective in a drawing will help you create a sense of depth. But even when you don't use perspective lines as guides, you'll find that understanding perspective will make landscape drawing easier, and result in more satisfying finished artwork.

PEN AND INK

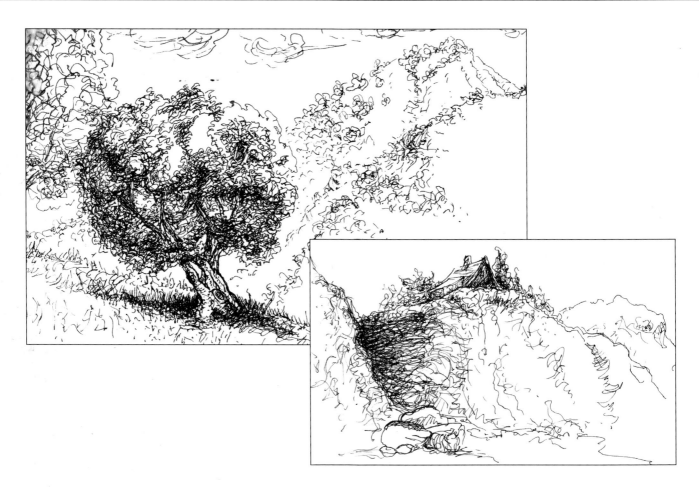

Until this point, you've probably been working in pencil and perhaps charcoal. If you'd like to draw landscapes in a more illustrative style, try a new medium: pen and ink.

For more information on types of pen and ink, see the Materials section on page 8.

Pen and ink is very different from pencil, charcoal, or Conté crayon. The soft shadows and tones you can achieve so easily with those media aren't possible with ink. You'll only have dark, crisp lines to work with. Additionally, you won't be able to erase. This creates a significant extra challenge, but the results can be beautiful, particularly in landscape drawing.

Creatively varying your lines and textures can compensate for the lack of soft tones. Instead of using light and dark lines to indicate distance from the viewer, try using thick and thin lines. Thick lines will look closer to the viewer, and thin lines will look farther away. Pressing harder with your pen will usually result in a thicker line.

Using the pattern and density of your lines to indicate light and shadow can produce rich, beautiful effects. There are many line texture techniques, but the principle generally behind them is this: **Denser, closer-together lines convey darker shades**, and **less dense, farther-apart lines convey lighter shades**. Once you know this, you can experiment to find your preferred pen and ink techniques. Try **crosshatching** (layering sets of lines going in opposite directions) or **stippling** (shading with many tiny dots of ink).

Combine ink shading techniques with thick and thin lines. If your lines follow the shape of the object you're shading (such as lines that wrap around the trunk of a tree), you can make the object feel doubly dimensional. The more you vary textures, using different kinds of marks for different parts of the landscape, the more interesting your drawings become.

HISTORICAL NOTE: Dutch artist Vincent van Gogh's sepia ink drawings of landscapes show how he employed all of these techniques. They're great examples to refer to and study. They are in sepia ink only, but they almost appear to be in full vibrant color because of the creative variation in the textures used.

Van Gogh's work also shows that sometimes, exaggeration can be more effective than accuracy. His art isn't perfectly faithful to his subject matter, but boldly conveys its essence.

Vincent van Gogh, *The Parsonage Garden at Neunen in Winter,* 1884

EXERCISE: Finished Landscape

Now that you've learned to draw foliage, use those methods and the skills you've picked up throughout the book to draw a completed landscape. It may be easier to draw from a photo or copy one of the drawings in the chapter at first. Try using pen and ink!

CHAPTER 10
DRAWING FACES

Portraits are easier than bottles or buildings.

My beginning level students look incredulous when they hear this. But like trees and plants, people are organic. Organic subjects are more forgiving than cups and bottles, which require crisp accurate edges and details.

Many students are intimidated by the thought of even trying portraits. But once they begin, they discover that they can create emotionally evocative, uniquely personal interpretations of the people they draw.

All of the rules and methods that I teach are tools only. Once they become second nature, and you don't have to think about them (like brushing your teeth in the morning while you are still half asleep), they can free you to express your innermost feelings. With portraiture you still need to use perspective, plumb lines, and other systems you've learned, but in a much looser and more intuitive way. Organic living lines and exaggeration can help make your portraits more meaningful. If you can, look at works by Egon Schiele. This great Austrian draftsman was a master of expressive drawing.

You'll find that if you loosely use plumb lines and ellipses as underlying guides—and draw energetically on top of them—your drawing will come to life.

Once the drawing techniques you've learned grow to be instinctive, your art can become a window into your unique inner world. This cannot be taught. It is magic.

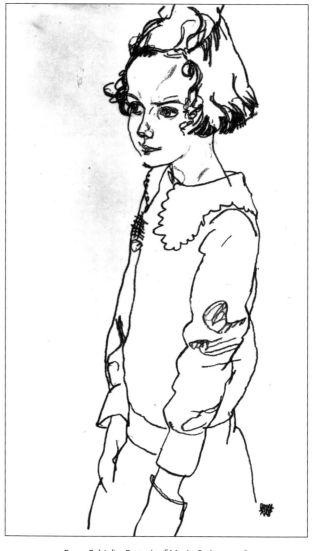

Egon Schiele, *Portrait of Maria Steiner*, 1918

AUTHOR'S NOTE: I grew up in the Bronx, New York, and never had a chance to play tennis. When I moved to the suburbs later in life, I started playing against a friend for exercise. My friend had grown up with tennis lessons, and of course he consistently beat me. One day (he must have been in a generous mood), he gave me some advice. He said, "Bruce, you have a terrific natural forehand, but your backhand is killing your game." He showed me how to change the way I held my racket. It took a little time and practice to learn, but now I can beat him consistently. It was such a simple thing, but it made a tremendous difference. Just like the drawing systems.

FACES LOOKING STRAIGHT AHEAD

All faces are unique, but most have the same basic structure. Below you'll find a guide to drawing a face from the front. When you draw someone's portrait, you can make slight adjustments to these proportions to depict their individual face.

The Head

Start by lightly sketching an **egg shape**.

Put a **vertical plumb line** through the center, cutting it in half. Then, add a **horizontal plumb line** that does the same, as you see in the illustrations below. The plumb lines should cross at the center of the egg shape, like a **bullseye**.

These plumb lines will first help you place the eyes, which are always in the center of the head on a straight face.

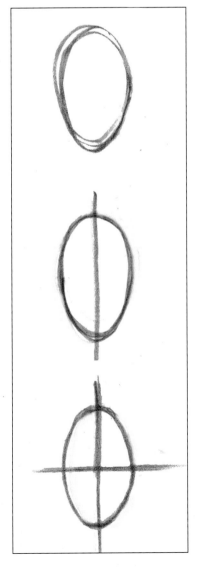

The Eyes

When you draw the eyes, keep in mind the following:

- The horizontal plumb line should cut through the center of the pupils.

- There is approximately one eye-length between the two eyes.

- A face is about five eye-lengths across.

- The eyeball is considerably smaller than the socket, as it has to comfortably fit inside of it, like a golf ball fits in the hole.

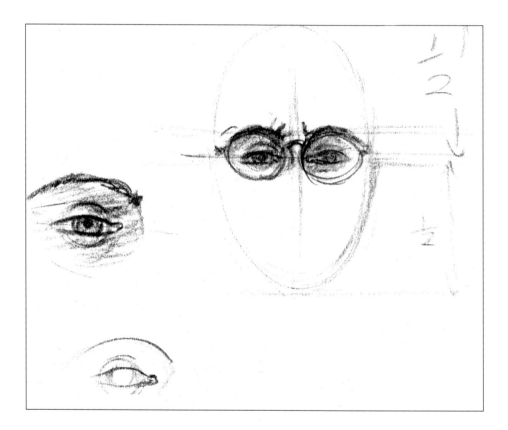

Begin drawing the eyes by lightly sketching the shape of the whole **eye socket**. Your eyes are slightly sunken in your face (to protect them), and the eye socket is the "valley" area around each eye. Anatomically speaking, eye sockets are the big hollows in your skull that contain your eyes and their accompanying muscles, tear ducts, etc. Their real shape is irregular, but you can pencil them in as ovals, or squares with rounded corners. Use the images above and on the next page to guide you.

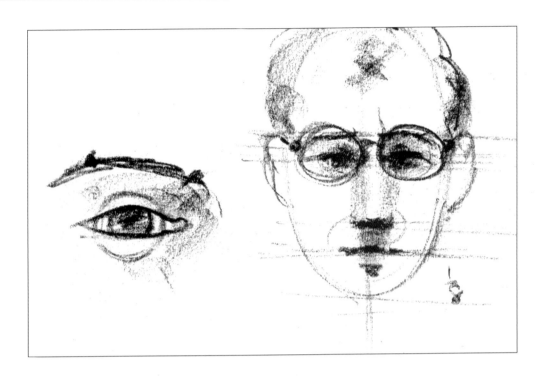

Once you've sketched the eye sockets, draw in the eyes. They should, as mentioned, be about **1/5 as wide as the head**, with **one eye-length between them**. It may make things easier to lightly sketch the whole eyeball at first, as a small circle within the larger socket. Drawing the eyeball will help you figure out the placement of the eyelids.

Place the dark **pupils** of the eyes on the **horizontal plumb line**. Add the contours of each eye around the pupil. Darken the **eyebrow**, which falls on the **upper ridge of the socket**.

When you shade a portrait, note that in normal lighting the inside of the eye socket will be in shadow, especially above the eye.

The Nose

Earlier, I called the place where the horizontal and vertical plumb lines intersect a **bullseye**. This bullseye is your reference point for the bridge of the nose.

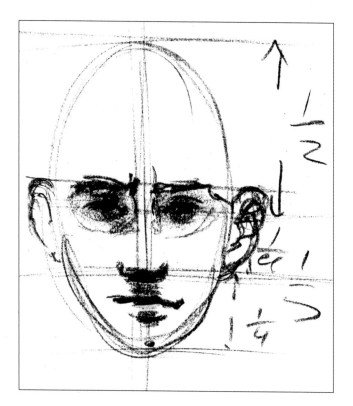

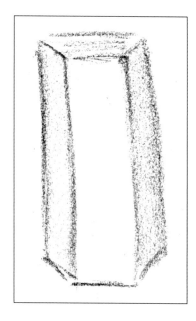

The bridge of the nose begins right between the eyes. If you run your finger down the center of your face, you'll notice that there's a "valley" right at the bullseye spot, and that your nose extends outward and broadens from there. Noses generally end about **halfway between the horizontal plumb line and the bottom of the chin**, as shown above. If it helps you, add another horizontal guideline where the bottom of the nose should be.

Noses may seem complicated, but really aren't. The nose is shaped like a **long box**. Its base is broader than its top. How wide and tall the box is varies greatly, but the basic structure remains the same.

The Mouth

The mouth sits halfway between the bottom of the nose and the bottom of the chin. In many cases, its corners line up with the pupil of each eye.

The upper lip tends to form a very loose "M" shape. It's generally thinner than the lower lip, and more shadowed.

The lower lip is in most cases fuller and lighter than the upper. You can often just suggest the lower lip with a bit of shadow underneath its center.

Right above the center of your top lip you'll notice a little indentation. This is called the *philtrum*, and in normal lighting it will be in shadow.

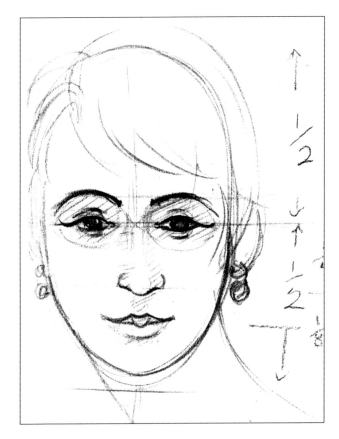

The Ears

Like all facial features, ears vary a lot in size and shape. But the top of the average ear is level with the eyebrow, and the bottom is level with the bottom of the nose.

Unless someone's ears stick out a lot, they'll appear shortened from side to side when seen from the front.

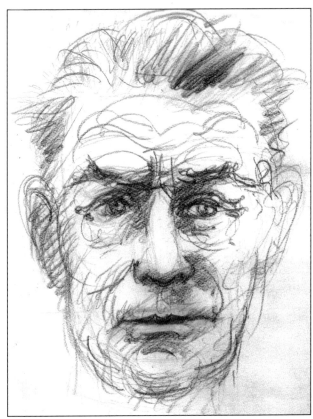

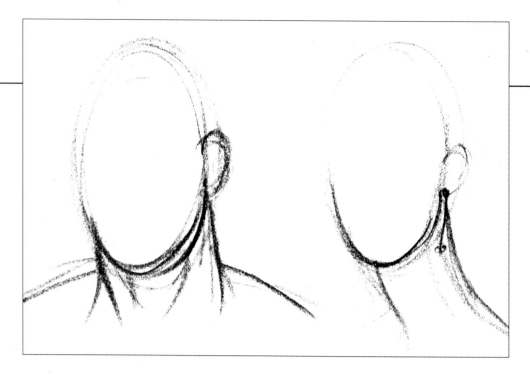

Masculine and Feminine

Masculine and feminine features don't differ as much as you might think. To make a portrait lean one way or the other, pay attention to the width of the shoulders and neck.

I intentionally made both faces blank in the illustrations above, and as similar to each other as possible. Yet you can guess the gender of the sitter in each portrait.

Women's shoulders tend to be less broad and more sloped, and men have more pronounced Adam's apples. Leonardo da Vinci's famous images of the Madonna have long graceful necks, like swans or gazelles. On the Sistine Chapel ceiling, many of Michelangelo's male figures have delicate features, but still look very masculine because of the thickness of their necks and torsos.

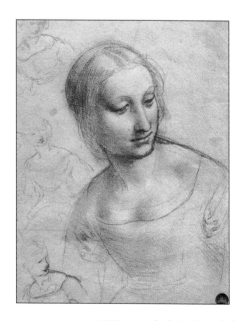
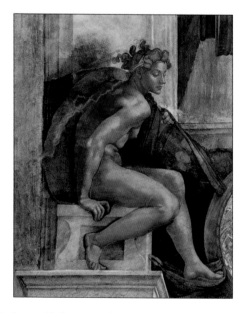

LEFT: Leonardo da Vinci, *Study for Madonna with the Yarnwinder*, c. 1501;
RIGHT: Michelangelo Buonarroti, detail from *The Drunkenness of Noah* on the Sistine Chapel ceiling, 1508–1512

Hair

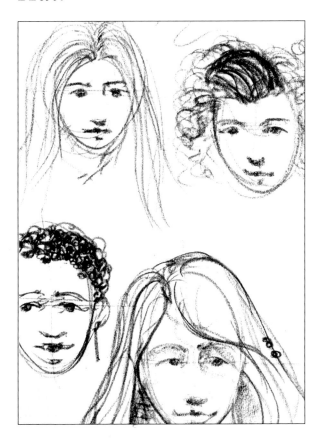

Hair has no solid structure of its own. Like clothing, it takes on the shape of what it is resting on, or what it wraps around (which is your skull).

To draw believable hair, ignore what you think you know about how hair looks, and instead scrutinize what you actually see. The main structure that affects hair is the shape of your head, which the hair sits on and exudes from. Try to make lines and marks consistent with the movement of the particular hairstyle you are looking at. If the hair is straight, use straight or gently curving lines. If it is wavy, use wavy lines. For curly hair, draw lines that curl consistently with the type of curly hair you are depicting.

Faces and Characters

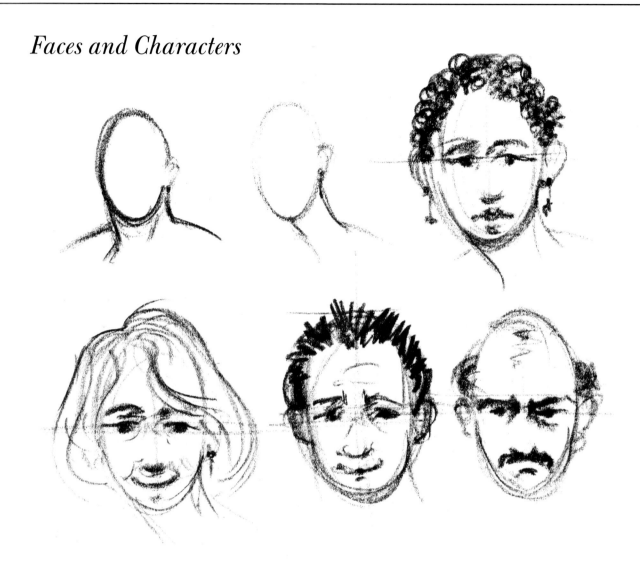

Above are sketches of different characters that I did using the methods described. Once you learn the basic proportions of the face, you can quickly make up characters from your imagination. You won't need reference to create a convincing person. This is a useful skill when you're illustrating a story or idea.

EXERCISE: Sketch a face

Referring to the instructions on the previous pages, draw three basic faces. Try to do so without looking at reference. If it's helpful, start by copying one of the example drawings, then make up your own when you have the hang of it.

EXERCISE: Shading a face

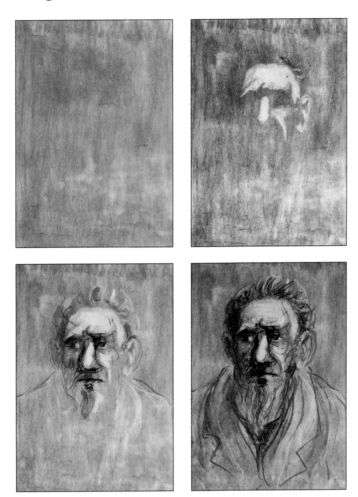

In Chapter 2 (on pages 24-25), you tried drawing by first darkening your entire sketch page, then erasing the light areas of the object you drew. Once you're comfortable with the basic proportions of the human face, this is a great way to learn to shade a portrait.

1. Choose a subject for your drawing: either a photograph or a real person. If you're drawing a real person, use a lamp to light their face, so that there's a lot of contrast between light and dark areas. Or pick a photograph that has this kind of lighting, if you can.

2. Cover the entirety of your paper as evenly as you can with pencil or soft charcoal.

3. With your eraser, begin to draw. Pull out the areas of light first, squinting at your reference to better see the shapes of the light and shadow. The image will have soft edges at this point.

4. Finish the drawing by putting in crisp dark edges and details.

This is the way the great Dutch masters, including Rembrandt, were taught. It can be very helpful to beginners who are overwhelmed with too much visual information. This approach forces you to just see the big shapes first.

FACIAL EXPRESSIONS

To draw different facial expressions, you'll start out just the way you begin when drawing a standard portrait. After you've drawn your egg shape and put in basic guidelines, additional guides will help you show emotion.

The Language of Eyebrows

The slant or arch of the eyebrows changes with a person's mood. This is most obvious when someone is very angry, very sad, or very happy.

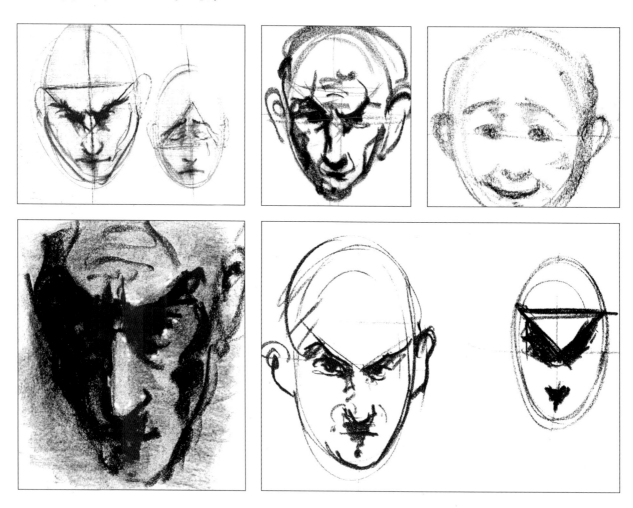

To depict emotions, use a **triangle** as a guide for the angle of the eyebrows.

Center the triangle on the face, with one tip on the vertical plumb line, as shown in the illustrations above. Point the triangle down for anger and other antagonistic emotions. Point it up for sadness, happiness, and surprise. The taller the triangle, the more extreme the emotion conveyed by the facial expression.

Anger

Eyebrows pulled close together and angled down toward the nose are the most distinctive feature of an angry face. A downturned mouth can also give the impression of anger. But further subtle adjustments can make a big difference in the type and intensity of anger your portrait conveys.

When drawing portraits that express anger, you may find it helpful to look at classic comic book characters as they go into battle. (Wolverine of the X-Men is a particularly good example.) Their expressions tend to be exaggerated, but looking closely at their features can help you identify what works.

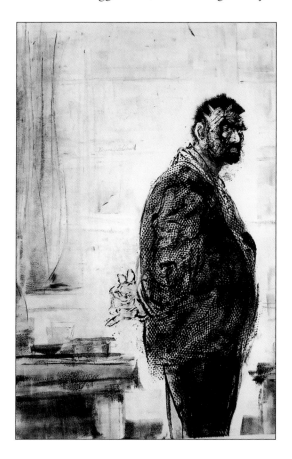
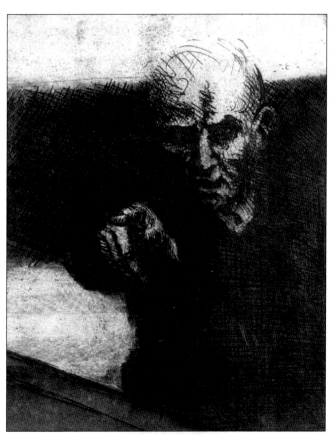

The illustrations above both depict anger, but in different ways. Notice how slight changes in the angles of the mouth and eyebrows subtly alter the expression.

Sadness

I use the sides of the triangle pointing upward to provide loose guidelines when I want to express variations of sadness. Below is a finished drawing displaying sadness, and the understructure for the man's sad face:

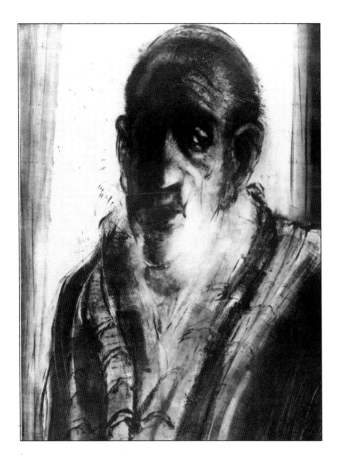

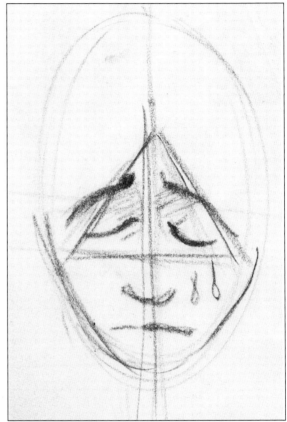

In the illustration to the right, I flipped the facial triangle both ways to show a pair of people with conflicting emotions. The woman is sad and the man is angry. Do you see how much the angles of the mouth and eyebrows do to convey the mood?

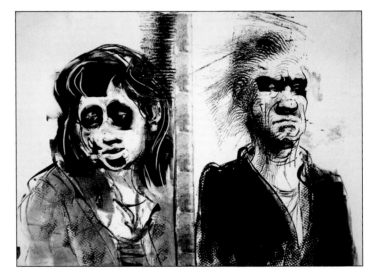

Happy, Smiling Faces

We all know upturned curves at each end of the mouth mean that someone is smiling. There's a difference in the eyebrows when people are smiling too, as you see in the sketch to the left.

On the smiling child's face, the brows sit gently on a rounded upward curve. Notice how the eyebrows and the mouth of the smiling child make a gentle continuous circular shape.

Variations in the angles of the brows and mouth can create a quizzical smile, or a rueful smile, as in the illustrations below.

Complex Emotions

Rarely is an emotion all one thing or another.

Rembrandt Harmenszoon van Rijn, *Self Portrait*, c. 1637. In classic art, Rembrandt's self-portraits demonstrate many subtle emotions. For further examples of sadness, look up some of the ones he did later in life.

Complex emotions such as bewilderment, confusion, irritation, disappointment, and suspicion can be expressed by subtle changes in the brows, eyes, and mouth, and by interchanging aspects of the three different basic expressions—anger, sadness, and happiness. The illustrations here are examples of varying emotions created by slight changes in the features.

EXERCISE: Happy, angry, and sad portraits

1. Find three photos depicting a happy person, a sad person, and an angry person. Search online, use your personal photos, or check newspapers or magazines. You can also simply make faces in a mirror.

2. Draw a quick portrait from each photo, using the guidelines you've learned. Don't forget the triangle!

3. If you're feeling adventurous, find a photo you think depicts a complex emotion. Draw a portrait from it, making note of the angles of the eyebrows and mouth.

PROFILES

Drawing faces from the side may seem complicated, but it's not. To structure a profile, you just need **two geometric shapes instead of one**.

The first is a **lightly-drawn egg shape**, just like the shape used to create a front-facing portrait. The second geometric shape is a **ball representing the back of the skull**.

Start your portrait by sketching the egg shape. For the frontal portrait, you used a vertical plumb line to divide the face in half, but now the egg shape represents half of the face and a vertical plumb line isn't needed.

However, the **horizontal plumb line** that cuts through the center is still used to place the eye and mark the bridge of the nose.

Also add guidelines for:

- **The bottom of the nose**, approximately halfway between the eye line and the bottom of the chin.

- **The mouth**, halfway between the bottom of the nose and the chin.

- A third guideline, about halfway between the eye line and the nose line, for **the back of the head**.

The semicircle representing the back of the head is about two-thirds as long as the egg shape. It starts at the top of the egg shape, and should meet it again at the guideline you drew halfway between the eye and nose lines. Look at the illustrations here for examples.

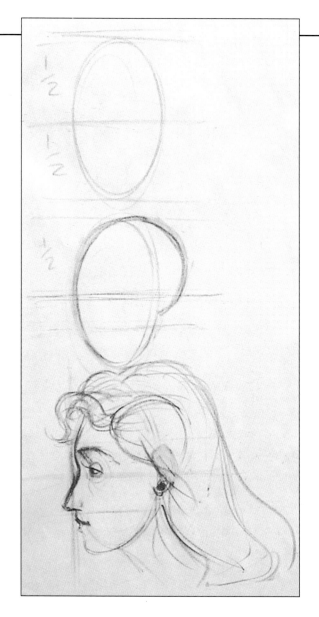

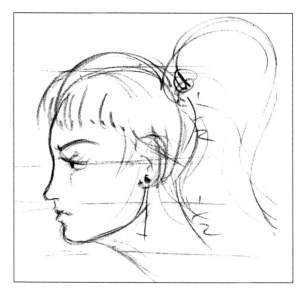

Once you've sketched your structuring shapes and guidelines, add a little indentation in the egg shape, right on the eye line. This is the beginning of the bridge of the nose.

Notice that there is space **between the eye and the outer contour of the face in a profile**. If the eye rests on the outer contour, the portrait will look like a cartoon.

As with a frontal portrait, begin the eye by lightly drawing the shape of the eye socket, and the eyeball inside it, keeping in mind that the eyeball is much smaller than the socket. Then draw the eyelids and the curved front of the eye between them. From the side, the eye looks almost triangular. It may help to note that in profile, you are seeing **half of the eye's full almond shape**. The eyebrow should sit on the eye socket's top ridge.

Keep in mind, when drawing the mouth and nose from a profile angle, that one side of each is over the horizon and out of sight. As with the eye, you can only see **the half of the mouth and nose that are turned toward you**.

Because the light is usually coming from above, and your upper lip curls inward, it is often in shadow. Light falls on the lower lip because it curls outward and catches the light. Shadow falls below the lower lip.

Remember to align the bottom of the nose with the guideline that falls **halfway between the eye line and the bottom of the chin**. Because the nose extends off the surface of the face, shadow usually falls below the nose.

In a profile, the end of the nostril basically lines up with the front of the eye socket, and the end of the mouth lines up approximately with the center of the socket. The outer contour of the brow and lips line up on the same vertical guideline.

There is approximately **a socket-length between the end of the eye socket and the beginning of the ear**. The top of the ear lines up roughly with the eyebrow, and the bottom should not extend below the nose line.

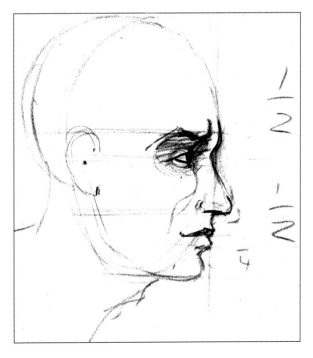

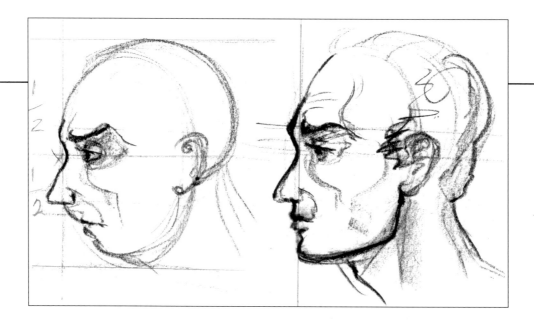

It's helpful to draw a **vertical guideline from the front of the eye socket down to the chin**. If you wanted to create a masculine portrait with a strong jaw, you would extend the jaw up to or beyond this guideline. To draw a person with a receding chin, or someone who has lost their teeth, pull the chin back away from the guideline.

In the sketch below, the line work is simplified and the curves are smoother and gentler because it portrays a young woman. Do you see how I used a guideline through the ear to position her shoulder?

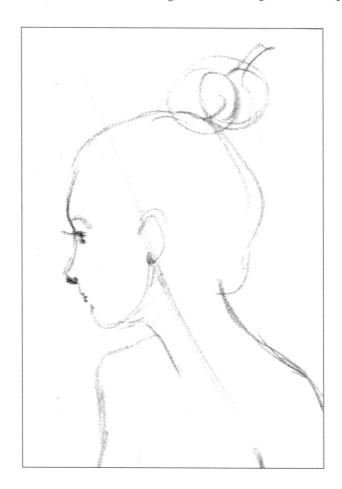

Subtle changes to these basic proportions can create huge changes in the person or character you're drawing. Compare the illustrations below for examples of what changing the size of the nose, the shape of the chin, and the sharpness of the brow can do.

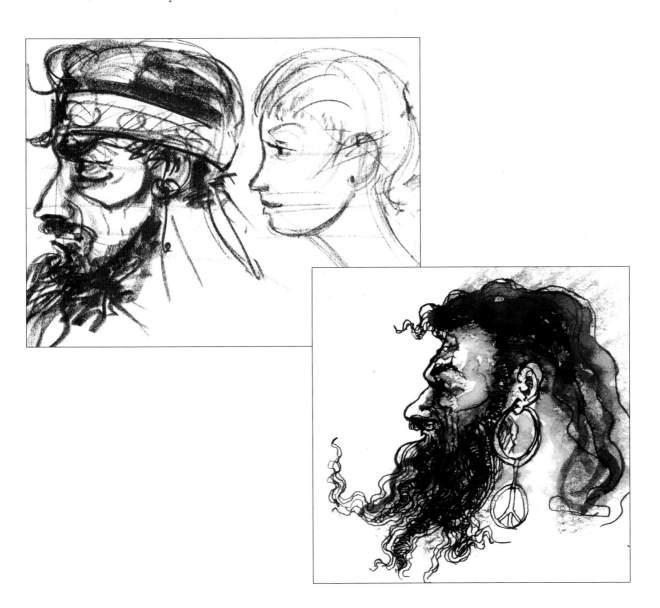

EXERCISE: Profiles

Draw a male and female portrait in profile using the methods and proportions discussed in this chapter. You can draw from life, photographs, or your imagination.

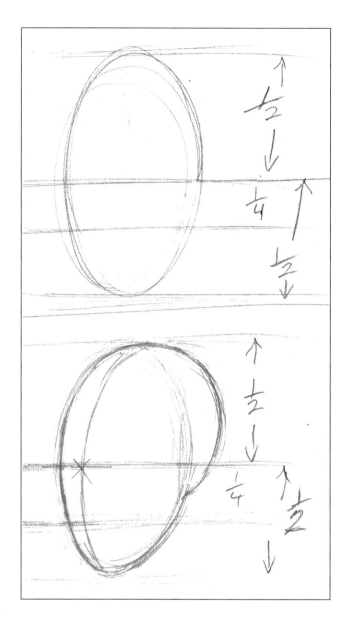

Three-quarter views can make for especially dramatic, dynamic portraits. To make them realistic, you'll need to understand how features become **foreshortened**—that is, look shorter due to the angle at which you're seeing them—as the head turns in space.

To draw a three-quarter view, begin with a lightly-drawn egg shape. This is the same way you began the frontal and profile portraits. As before, you'll use a horizontal plumb line that cuts through the center of the egg shape to place the eyes. The bottom-of-nose guideline will fall halfway between the eye guideline and the chin, and the mouth guideline will in turn fall halfway between the nose guideline and the chin.

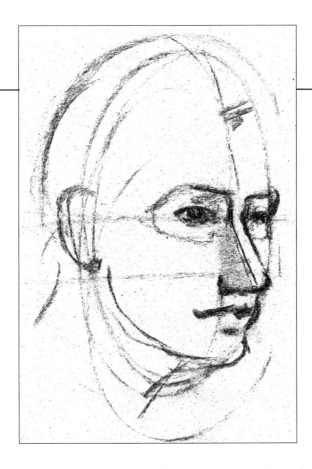

Once you've added the horizontal guidelines, place the **vertical plumb line**. This plumb line is important, as it determines the angle of the head.

The vertical plumb line no longer appears as a straight line, as it does from the front, and it is not the outer contour as it is for a profile. In a three-quarter view, the vertical plumb line appears inside the head and **curves around the head, consistent with the shape of the outer contour**. The closer it gets to the outer contour—the edge of the face—the more extreme the angle of the three-quarter view.

Remember: Your head is round like an apple, not flat like a plate. As soon as your head starts to turn, **the side that is turning away from you gets smaller and smaller**, until it turns into a profile.

Because the ball shape in the back of the head is turning away from you, it will appear smaller than it does in a profile. **The closer the vertical plumb line is to the center of the head, the less you will see of the ball in the back of the head.** As with profiles, the bottom of the ball meets the egg shape about halfway between the eye and nose lines.

As always, the top of the ear on a straight three-quarter view lines up with the eyebrow, and the bottom of the ear should not go below the nose line. There is approximately one socket-length again between the end of the eye socket and the beginning of the ear.

Once you've set up the basic structure of the face, you can use your guidelines to add the features.

How Features Turn in Space

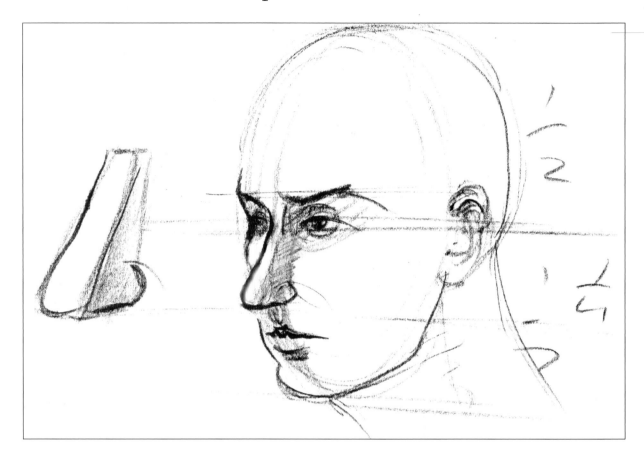

In a frontal portrait, you can see both side panels of the nose, but in a three-quarter view, the side that is turned away from you is out of sight. **You'll generally only be able to see the top and near side of the nose**. Even though you can't see the whole nose, lightly drawing a "nose box" using one-point perspective will help you with this feature.

Throughout this chapter, we've been thinking of the head as an egg shape. But for the purpose of understanding how facial features turn in space, it may be helpful to temporarily think of it as a cylinder instead.

In the illustration to the right, you can see a series of mouths on a cylinder. As the cylinder rotates away from you, the nearer side of the mouth becomes very slightly shortened. **The far side of the mouth, however, becomes shorter and shorter**, eventually disappearing altogether when viewed from the side.

If you're wondering how the face's features should look from a particular three-quarter-view angle, try lightly sketching a cylinder around your drawing of the head. Imagine the features from the front view first, and then picture them rotating so that they're aligned with the vertical plumb line. No matter what view you're drawing, using a cylinder can help to remind you that the head is rounded, and the features curve around it.

The illustration below shows the guidelines used to draw a three-quarter view of a man who is looking slightly downward.

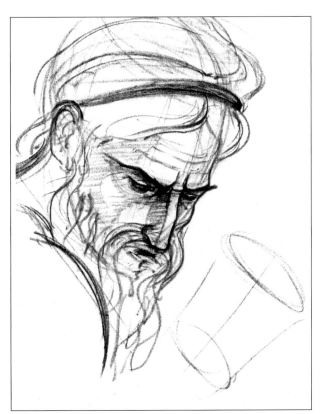

Put Drama in Your Drawings

The drawings below will give you some ideas about how you can use these systems to create characters who evoke different emotions. My intention in each was to use the three-quarter view to create an intense, poignant mood.

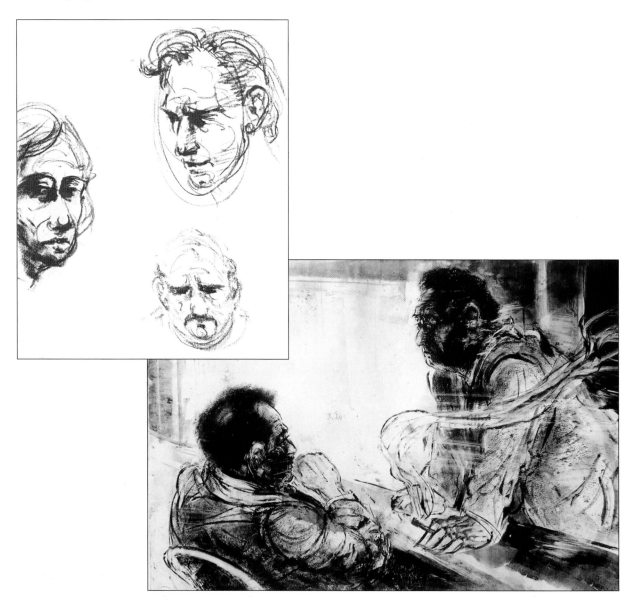

EXERCISE: Three-quarter view

Draw a portrait in three-quarter view using the step-by-step method you've learned in this chapter. Use reference.

EXTREME ANGLES

Extreme angles can give your drawings drama, impact, and power!

Drawing faces from above, below, and other odd angles, instead of straight on, is among the most effective tools an artist has to convey extreme emotions. Viewing a person from below can make them loom large and intimidating. Portraits from above give the impression that someone has the weight of the world on their shoulders, or is all alone in the world.

Plumb Lines and Ellipses

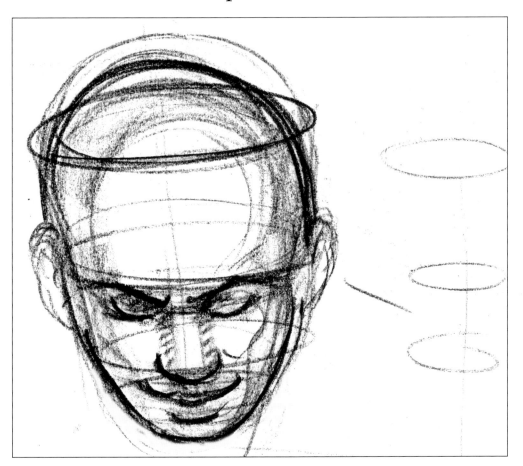

As you began to learn in the section on three-quarter view, when you're drawing a person's head from a perspective other than straight-on front or profile, the plumb lines and other guidelines affected by the change in viewing angle will **curve around the head**, instead of appearing straight.

In the portrait above, the head isn't turned to either side, so the vertical plumb line appears straight. However, the head is looking down (or we're viewing it from above), so the **horizontal plumb lines (which are ellipses) will curve downward reflecting the angle of the head**.

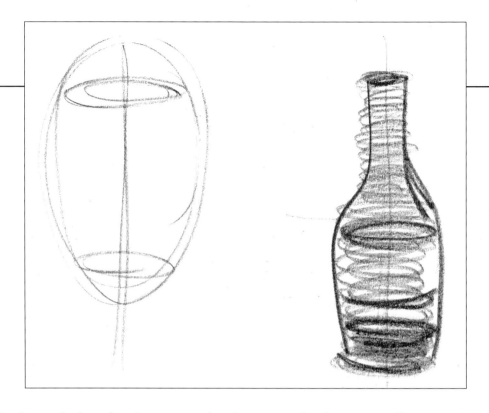

Just as you've learned when drawing a cup or bottle, you need to keep your ellipses consistent. All of your horizontal guidelines should match. It may help you to draw the entire ellipse, front and back.

Because the head is angled downward, the bullseye (where the horizontal and vertical plumb lines meet) is far down on the face. The closer this point gets to the bottom contour, the more extreme the downward angle. The reverse is true of upward angles.

Notice in the top illustration to the right that the ears are much lower down on the contour of the head than the eyes. This is because they still sit on the ellipse of the horizontal plumb line, lined up with the brow. The ellipse curves down toward the sides of the head, so the ears are placed lower. In the bottom sketch the reverse is true, as the ears sit well above the eyes because of the viewing angle.

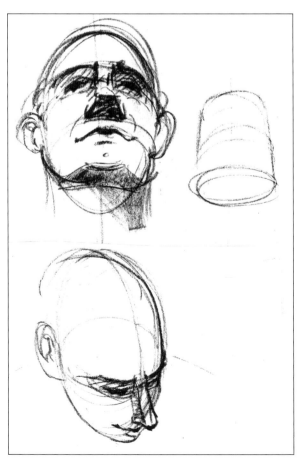

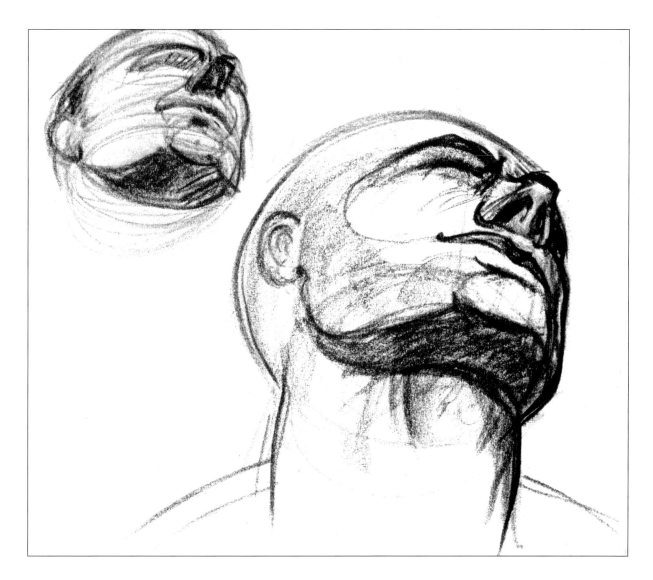

The image above is drawn as if we're looking upward from an extreme position underneath the head. Notice how close the point where the horizontal and vertical plumb lines meet is to the top of the head. This is exactly the opposite of how they meet in a downward angle.

You may notice, when you draw faces from unusual angles, that **the rules you've learned for facial proportions no longer precisely apply**. In the perspective chapters you explored the way objects farther away from the viewer look smaller, and closer objects look larger. This basic principle is why facial proportions distort a little from odd angles: Some of the features are markedly closer to you than others. So although the space between the nose and the mouth is about equal to the space between the mouth and the chin, in the drawing above the latter looks much larger because the chin is closer to you. Additionally, because the head is rounded, the curvature of the face blocks farther-away features from view altogether at some extreme angles.

The best way to understand how the face's proportions scale from different viewpoints is simply to practice drawing them from observation. Look closely at real faces from odd angles, in either photos or life, and try to draw them as sensitively as you can. You'll soon develop a feel for how the head looks at different angles. But don't forget to use your ellipses, and keep them consistent, as they can still help you to properly place the features.

DRAWING TIP: In addition to the vertical and horizontal plumb lines, which wrap around the head, a straight central axis line that runs through the center of the head to establish the head's angle is very important. The illustration below demonstrates this.

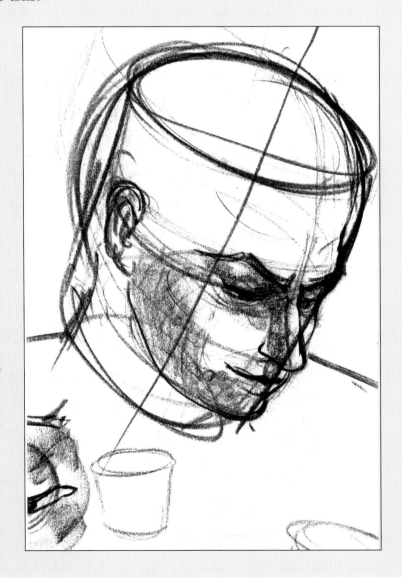

FACIAL FEATURES

To the left, the eye is shown from above and below. Notice how the angles of the eyelids, eyeball, and eyebrow change much like the ellipses on a cup or bottle as your viewing angle changes. Other features curve up or down in similar ways.

Below are further examples of how to structure upward and downward angles. Notice how the nose and ears are placed in the portraits, and how different portions of the features are visible. Looking at these images, you'll also begin to see the variety of emotions extreme angles can convey.

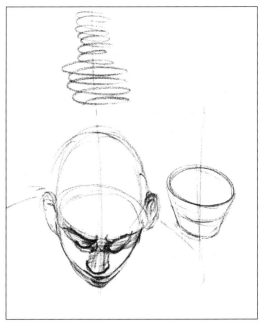

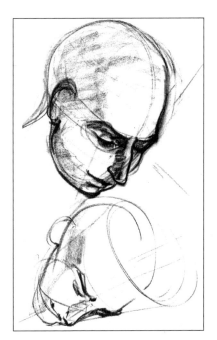

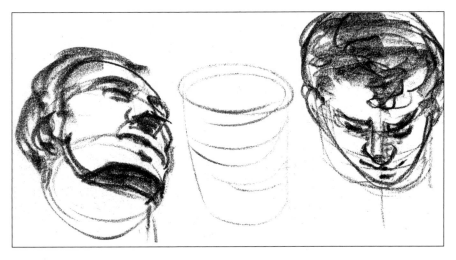

When I was working on the *Iron John* book jacket to the left, the art director told me to try to make the portrait as dynamic and striking as possible, so I chose an underneath angle for drama and impact. It made the character appear larger than life.

In the drawing to the right, the assignment was to make the figure as frightening as possible. I did it by again viewing the figure from below to make him look large and menacing, and by using a strong graphic composition with high contrast light and shadow for impact.

The illustration above uses the downward angle to evoke a feeling of loneliness and introspection.

When you want to capture a particular feeling with a portrait, especially a complex mood, experiment with different angles in your thumbnails. Viewpoint can drastically change how characters and scenes are perceived.

Leonardo da Vinci, *The Last Supper*, c. 1495–1498

AUTHOR'S NOTE: When my students complain that using plumb lines is tedious, I tell them about Leonardo da Vinci's sketches for his great fresco, *The Last Supper*. A number of years ago, the sketches were on exhibit at the Metropolitan Museum of Art in New York. I was able to attend the exhibit and study his numerous drawings for this masterpiece intensely.

He drew many variations to work out the arrangement of the 12 apostles. He worked on the position of each apostle, and the portraits were drawn from all possible angles: up and down, straight on, three-quarter view, etc. I was amazed to see that at an advanced stage of his life, Leonardo da Vinci, one of the greatest draftsmen in history, used plumb lines in his sketches to keep the angles convincing and structurally sound. So I tell my students, if Leonardo needed plumb lines, then we all do!

EXERCISE: Portraits from above and below

Using the systems explained and outlined in this chapter, create two portraits, one viewed from above and the other from below. It's important to use reference for this, especially at first! Draw from photos, look at another person, or, if you have a mirror you can position below or above you, draw yourself.

CHAPTER 11
THE HUMAN FIGURE

The human figure is complex and variable. But like most things, it becomes comprehensible if you understand its proportions and use shapes, ellipses, and plumb lines as underlying guides.

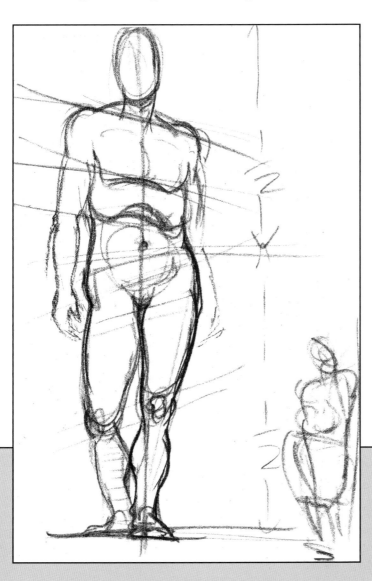

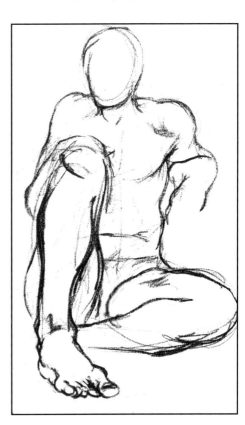

THE PLUMB LINE

In drawing the full human figure, we start out with a **vertical plumb line that runs directly through the center of the torso**. The plumb line will keep the figure visually standing straight up, exactly as it does with bottles. (We don't want our figures to look like they're falling down.)

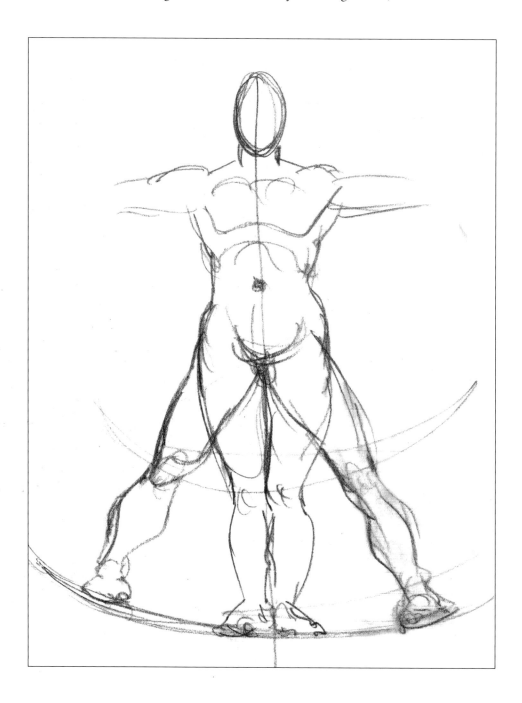

FUNDAMENTAL PROPORTIONS

HISTORICAL NOTE: You may have seen the image pictured at right before. It's Leonardo da Vinci's *Vitruvian Man*, and is among history's most famous explorations of human proportions. It demonstrates the Roman architect Vitruvius's study of the ratios that govern the human body. Da Vinci makes copious and exacting notes on the body's dimensions, but you don't need precise knowledge of each and every measurement to begin drawing the figure. In the chapter ahead, you'll learn the key things to keep in mind as you draw.

Leonardo da Vinci, *Vitruvian Man*, c. 1492

The full standing human figure is approximately **six-and-a-half to eight heads high, with seven being the average**. When the figure is standing at attention, the plumb line runs directly through the middle of the torso and hits the ground centered between the two feet, as both legs are holding up the weight of the body equally. The shoulders, hips, and knees are lined up straight and perpendicular to the vertical plumb line.

AUTHOR'S NOTE: Fashion illustrators often are trained to draw figures eight heads high to make the models look elegant and beautiful. In the *Lord of the Rings* movies, the elves were also proportioned this way to give them other-worldly grace.

THE FOUR QUARTERS

The center of the pelvic girdle (the hips) is halfway between the top of the head and the bottom of the feet. On a standing figure, the horizontal plumb line is located here, cutting the figure in half top to bottom.

Think of the figure's height as divided into four quarters:

- From the bottom of the foot to the kneecap is one fourth of the height of the figure.
- From the kneecap to the center of the hips is another fourth.
- From the hip to the top of the ribcage is the next.
- From the top of the ribcage to the top of the head is the final quarter.

Note again that you needn't adhere to these measurements with absolute precision, but your figures should correspond roughly to them.

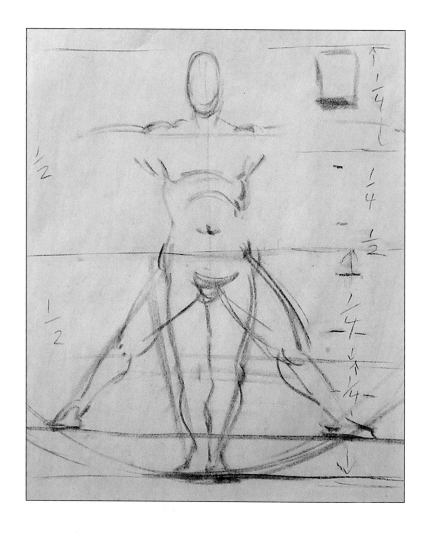

STANDING IN CONTRAPPOSTO

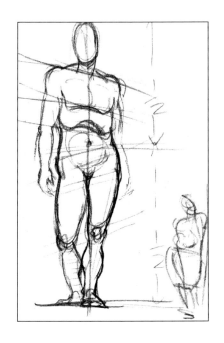

When figures are standing with their weight shifted onto one leg, it is called *contrapposto*, or counterpose. Many classic sculptures of biblical figures (Michelangelo's and Donatello's *Davids*, for example) and the gods and heroes from ancient Greek mythology are often depicted in this position, which connoted spiritual elevation and beauty.

When the weight of the body is on one leg, the hip is higher on the side that is holding the weight, and the other side drops lower. The knees match the angle of the hips. The knee of the leg not supporting the body's weight will be more bent. In order to balance the body so that it can stay upright, the shoulders angle themselves in the opposite direction of the hips, like an accordion.

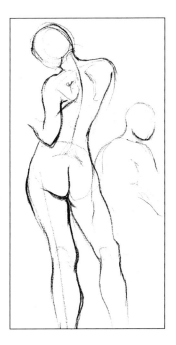

DRAWING MALE AND FEMALE FIGURES

The systems and measurements for male and female figures are exactly the same except that women's hips are usually wider than their shoulders. Men are usually proportioned the opposite way, with shoulders wider than their hips.

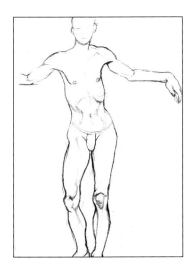
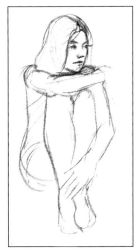
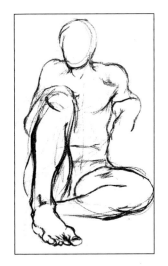
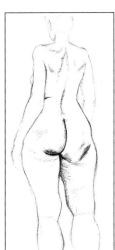

USING GEOMETRIC OBJECTS AS GUIDES

Arms and legs are roughly cylindrical in structure. When drawing limbs, it may be helpful to draw tube or pipe shapes underneath them as guides.

In addition to geometric shapes, simple guidelines showing the overall angle of a portion of the body will help you capture a particular pose.

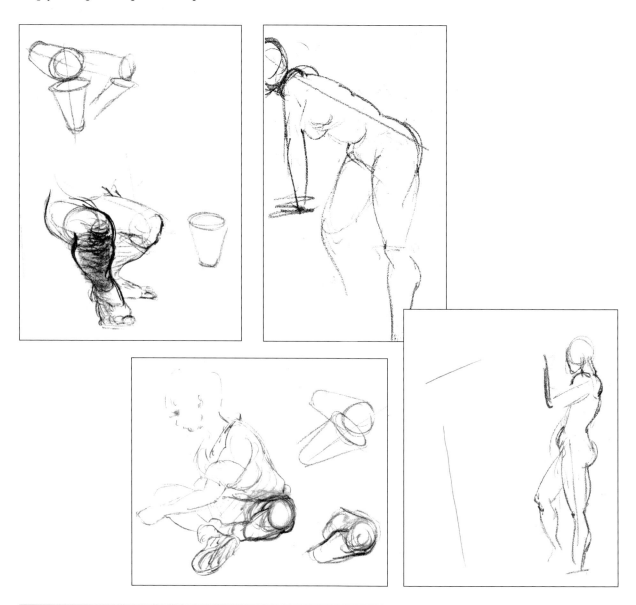

EXERCISE: The figure

Copy one of the figure drawings in this chapter using the systems you've learned. Once you've gotten comfortable copying the illustrations, try drawing a full standing figure from a photograph or a real person.

GESTURE DRAWINGS

The illustrations below are gesture drawings of both male and female figures. These quick drawings try to capture the feeling and essence of the pose without drawing all of the details.

Systems will give you an understanding of the figure's proportions, but gesture drawings will teach you how to depict the way bodies move and turn in space. In a gesture drawing, you don't worry as much about getting all the ratios exactly right. Instead you focus on quickly communicating the essence of your subject's pose or movement, using simple lines. If the figure is leaning to one side, it's helpful to draw a line that runs through the central axis of the torso on the same angle that the figure is leaning.

In each drawing, notice how a "living line" gives them a feeling of movement.

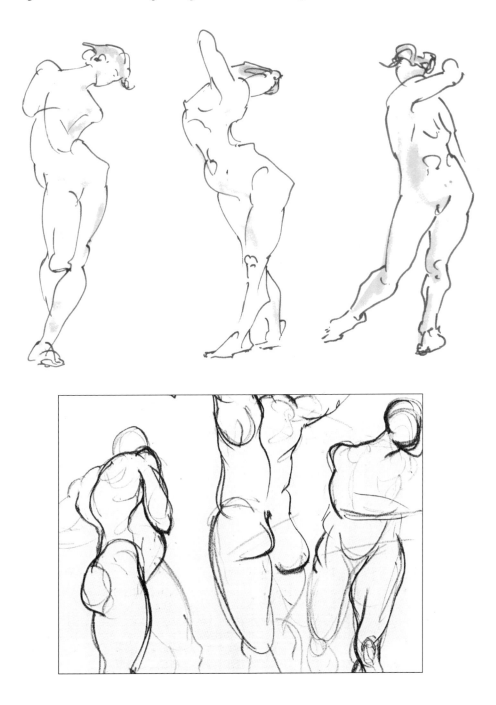

EXERCISE: Gesture

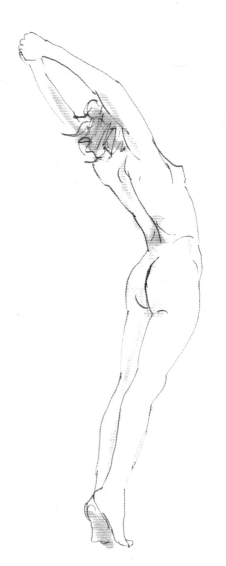

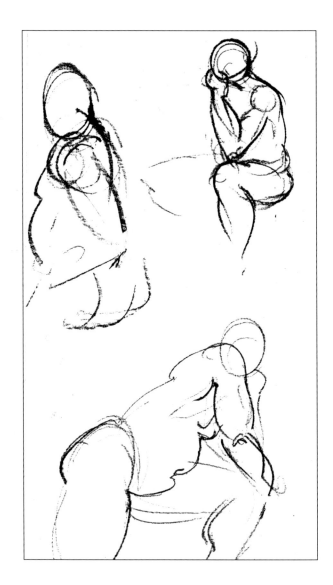

Do 5 to 10 gesture drawings, using energetic line to depict your subjects' movement. Draw from life if possible. Don't worry about finding someone to sit still for you; just try to **capture** *the essence and feeling of someone's pose* in the few seconds before they shift. Remember that you do not have time for details. It doesn't matter if you run out of time before you finish the figure in some drawings.

If it's impossible for you to draw from life, use photos of your choice, but impose a time limit on yourself. Take no more than 30 seconds per drawing at first, then allow yourself one minute, and finally two. This may seem dauntingly brief, but will force you to draw instinctively without overthinking.

Hands Also Need Guidelines

There are **four fingers**, or digits: the **index finger** (the one closest to the thumb), or forefinger; the **middle finger**; the **ring finger**; and the **little finger**, or pinky. For most of us, the middle finger is the longest. The index and ring fingers are slightly shorter, and the pinky is shorter still.

You might think these fingers and the thumb are the most important part of a hand, but when you are drawing, **the palm (or the back of your hand) should come first**, because the fingers extend from it.

I tell my students that drawing the fingers first may get them into trouble. If drawn first, fingers often end up looking like the tentacles of an octopus, or cooked spaghetti.

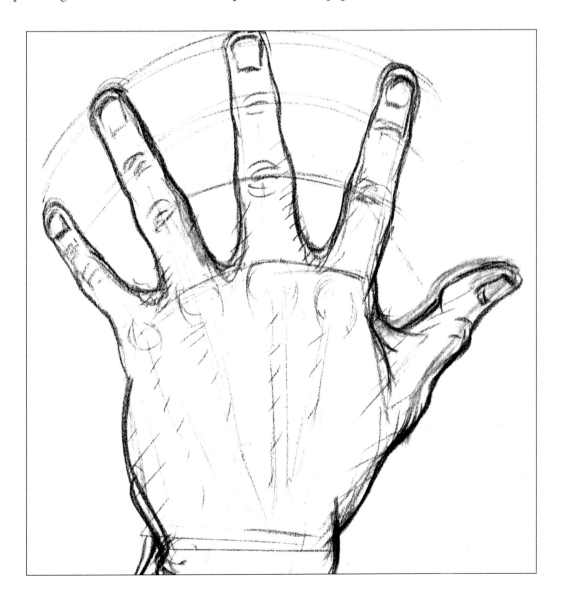

How to Draw the Palm

As with other body parts, finding a geometric shape similar to the form you want to draw can be very helpful. **The palm is a five-sided shape; it's like an uneven pentagon.** So I usually draw a pentagon using straight lines first.

Then, I draw **the curve that the fingers extend out from**. This curved line also helps establish the placement of the knuckles. You'll want curved lines to mark the two joints above the knuckles, and you'll want the arcs of these lines to be consistent. The guideline for the ends of the fingers curves in the same way.

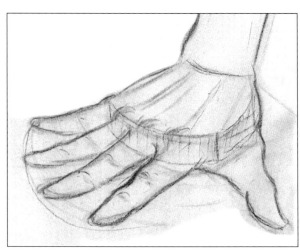

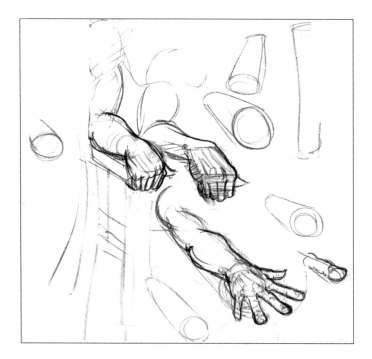

We've talked about using cylinders as guides for the body's shape (see page 132). You'll find it helps to use a three-dimensional geometric form as a guide under the palm as well.

Thumbs Are from Mars and Fingers Are from Venus

The **thumb** consists of a **knuckle and only one joint**, not two. It's very different from the four fingers, which all have a similar structure: knuckles and **two joints each**.

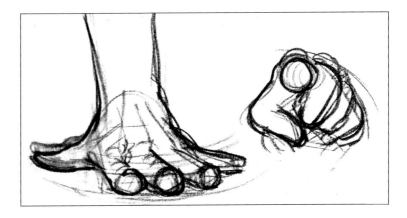

Drawing a Fist

Showing a fist or a closed hand is in some ways simpler than showing a hand with the fingers outstretched. A fist or a closed hand can be represented by a **simple geometric shape like a box** or a block of wood.

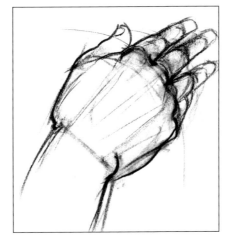

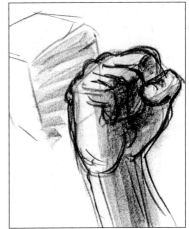

Draw the four fingers as a block, and then draw in each individual finger and the thumb. It's easier to add the fingers once the basic structure of the palm and knuckles are established. You can draw hands in differing positions using this system.

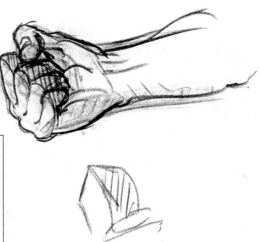

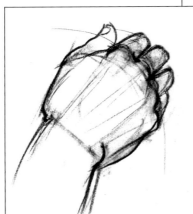

Go Big!

Your hands are large. You can cover your face with a hand. Try it! When drawing hands, don't skimp.

Hands Express Affection

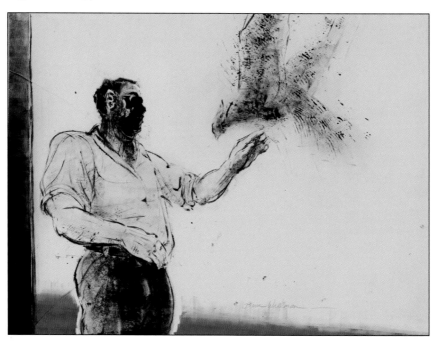

Bird Man

Bird Man uses a gentle gesture of the hand to express companionship between a large powerful man and a bird.

In the illustration below, the woman's hands help express the feeling of affection she has for the horse.

Darker Emotions

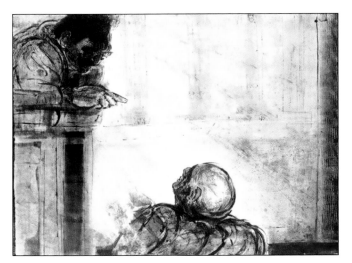

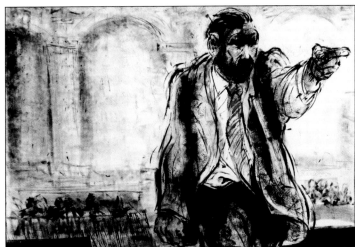

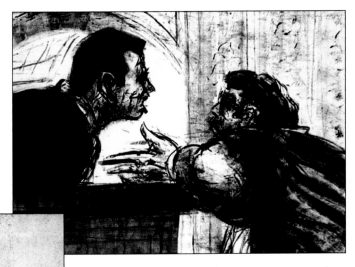

In the courtroom scenes above, notice the subtle changes in the positioning of the hands. The gestures are immediately recognizable: accusatory, threatening, exasperated, pleading.

Stiff, tense hands can telegraph stress, and extreme contortion as shown at the left can suggest that a person is having an anxiety attack.

Expressing Other Emotions

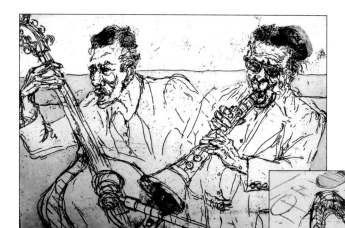

The detailed hands in these pictures of jazz musicians help catch the moment and give the image a feeling for rhythm and movement. Notice the way the musicians cradle their instruments.

Merged hands are visualized as one solid form to express closeness between two human beings.

The positioning of the hands and the figure at right convey desperation and anguish. This emotion is clearly expressed by the hands and body only, as the face is covered.

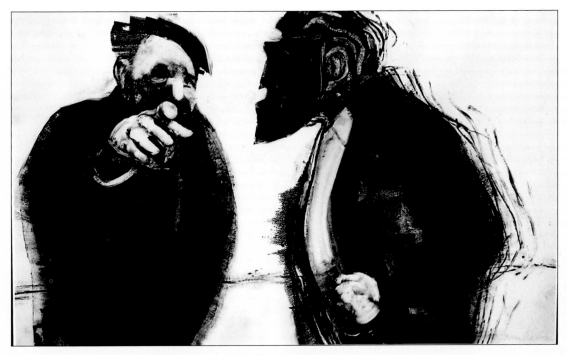

The Accusation

AUTHOR'S NOTE: Nothing is more intimidating than having someone point at you, like the figure above. Even more disturbing: The man next to him is wearing a black mask. Together, they put a "whammy" on the viewer. I created this piece after completing a *Phantom of the Opera* illustration for *People* magazine when the Broadway show opened. I'd had a hard time getting the *Phantom* mask right, and was asked to re-do it four times. This was stressful, as it was the first major commission I'd ever received. After my illustration was finally accepted, I was so relieved I rushed back to the studio to have some fun. I wanted to make the two guys here look like hit men. Halfway through, with one complete and the other still a block of black ink, I went for coffee. When I returned, I thought the ink resembled a mask. It seemed the *Phantom* project was still on my mind, so I went with the feeling and worked the ink into a mask. This made the piece much more powerful; the print later won a couple of awards.

EXERCISE: Drawing hands

Draw hands in different positions. Remember: Start by using an uneven pentagon shape to represent the palm, or draw the four fingers as a block. Then draw the individual fingers, and the thumb.

You can use your own hands for reference, or photos, or copy some of the drawings in this book. Hands are challenging, but can add enormous impact to your drawings.

DRAWING FEET

Seeing Feet as Slippers

When drawing feet, start out by picturing the shape of a **slipper** or **shoe**, or maybe a footprint in the snow. Thinking this way can help you see the basic structure of a foot without getting confused by the details. Drawing a slipper or a shoe first can also help you separate the top structure of the foot from the bottom, or sole.

Take These Four Steps

Here's a four-step (no pun intended!) progression that builds from a simple slipper shape at the bottom of the sole into a foot with all of its parts.

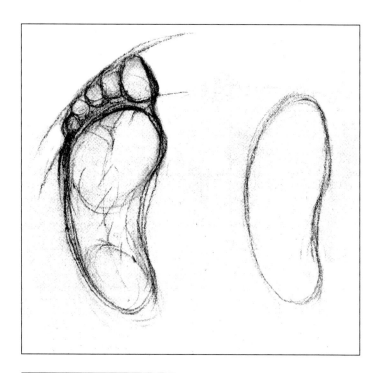

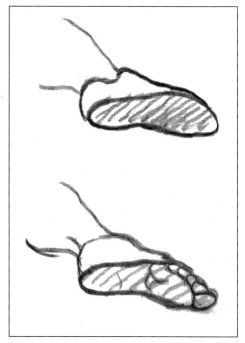

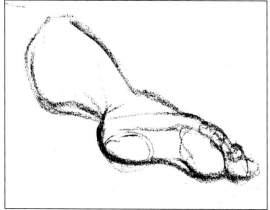

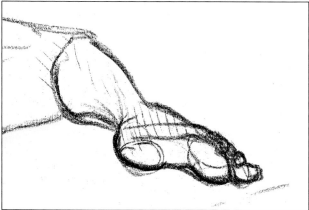

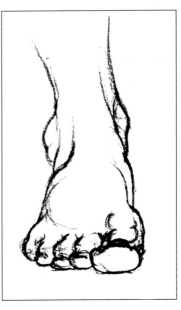

It's important to get the basic shapes first, so **draw the toes in as one block to start**. You can define each individual toe later. Like the fingers on the hand, if you try to draw each toe individually before sketching the block, you will get into trouble.

Notice that for both the front and side views of the foot, geometric shapes are used as guides and the toes are initially drawn as one simple shape.

These examples show what happens to the foot as it bends and turns.

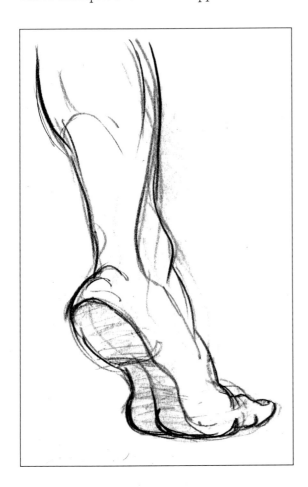

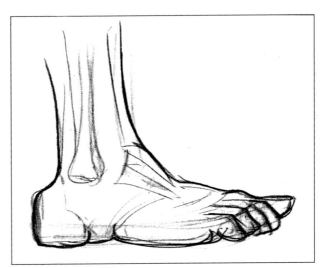

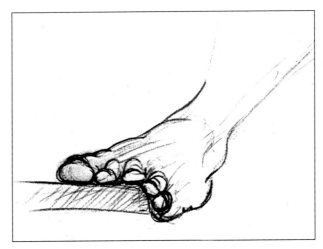

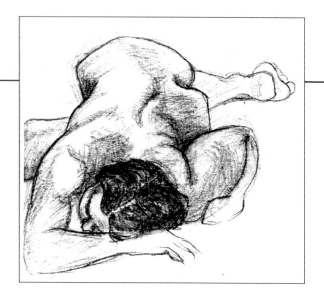
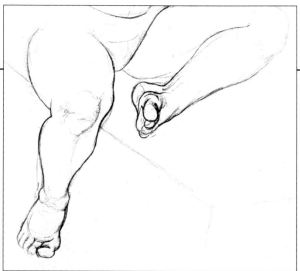

You may find it helpful to take a shoe, turn it to different angles, and draw it from various perspectives. This will increase your understanding of the basic structure of a foot.

As the finished piece below shows, you can compose illustrations that use feet to enhance the feeling of the whole image.

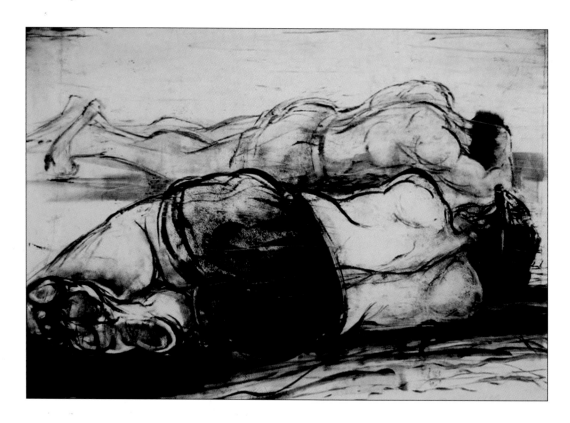

EXERCISE: Drawing feet

Sketch shoes and slippers to give yourself a quick overall feel for the shape of the foot. Then try drawing your own feet or someone else's from life.

CHAPTER 12
DRAWING ANIMALS

Drawing animals can be freeing, and also a lot of fun.

The same systems taught in earlier chapters for drawing both inanimate objects and other living things also apply to animals. Because animals are organic beings, like humans, trees, and plants, exaggeration and personal interpretation can infuse your depictions with life. The use of living line, along with direct spontaneous drawing, will give your animals personality and a feeling of movement.

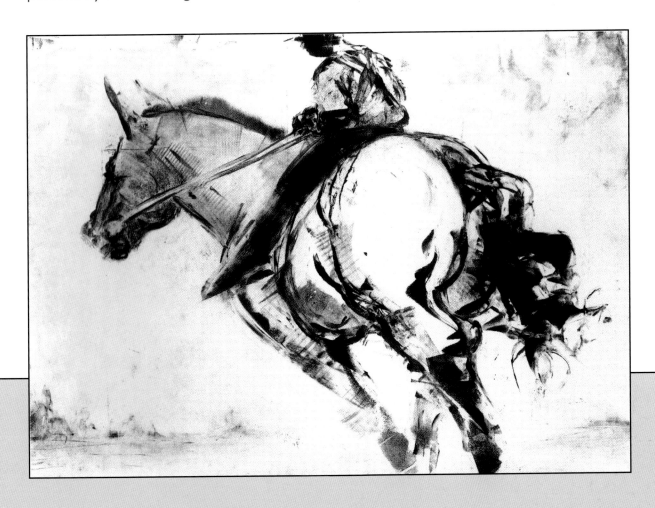

AUTHOR'S NOTE: At a show in New York a few years ago called "The Spirit of the Animal," I was invited to display a number of my large rhino and horse monoprint pieces. Someone approached me at the opening and asked me, "How did you make your animals look so alive? They look like they are moving and jumping right off the walls." I told her that the reason they look like they are moving is because I was moving when I drew them.

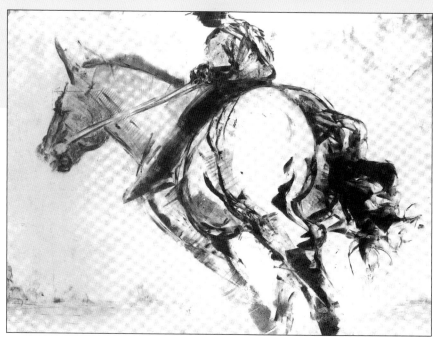

DRAWING AROUND THE SPINE

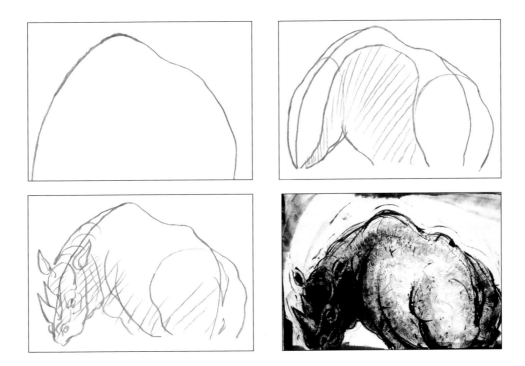

It's often helpful to **visually identify the spine line** of the animal, and begin your drawing with that line. This will dictate the animal's position and/or movement.

Once you have drawn the spine line, try to see the general structure of the animal's body. Break it down into **a few big shapes**. Don't worry about little details or quirks of line just now. Draw the animal as a handful of large, basic forms. Be sure the forms follow the spine line.

Once you've identified the underlying shapes, draw the contours and details of the animal over these guidelines.

Defining the animal in basic lines and shapes at the start of your drawing will make the finished animal look solid and real. It will help you draw a physically plausible creature, even if you haven't sketched this particular animal before and are unfamiliar with its anatomy.

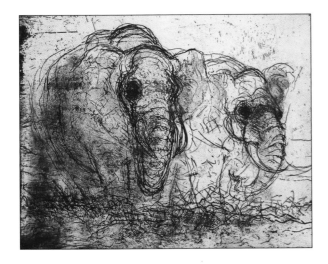

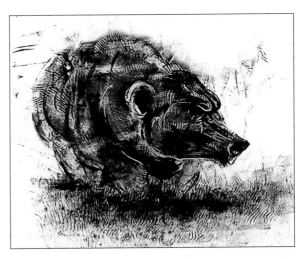

USING GEOMETRIC SHAPES

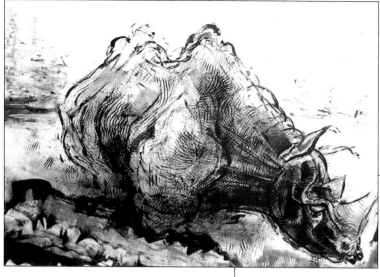

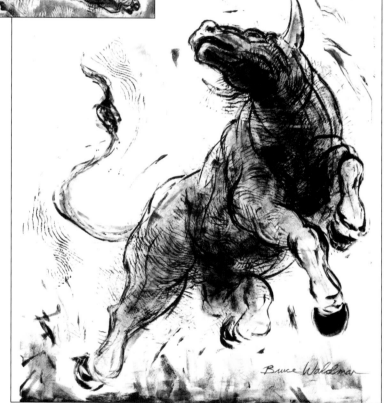

The anatomy of many animals is similar to that of humans.

As with human limbs, try using **tube-shapes as guides for animals' legs.** Boxes and other geometric forms can serve as understructure for animals' torsos. An elephant's or horse's leg, for example, is roughly cylindrical just like a human leg, and can be approached and drawn in the same manner. Using a central axis line as a guide for the angle of the limb, referencing the spine, and keeping your ellipses consistent can work just like it does for bottles and for people.

In the illustration above, notice how the bull's front legs are coming at the viewer in an extreme foreshortened angle. You can clearly see their cylindrical structure.

Some animal torsos, such as those of bulls and rhinos, are distinctly barrel-shaped. Try understructuring these torsos with a cylinder that bulges out in the middle.

Monkey and gorilla faces are proportioned and structured similarly to those of humans. (See Chapter 10, pages 93–126.) Just like people, their eyes are in the center of their heads, their heads are round—a little rounder than ours, in fact—and vertical and horizontal plumb lines function in the same way. This is also true of most dogs and cats.

Drawing horses' tails, a bear's fur, or rhinos' thick textured skin **relies more on close observation than on a predictable system**. Animal hair and skin work like human hair or clothing, which have no solid structure of their own and take on the structure of whatever they are enveloping or covering. In this case, that's typically the animal's body. If you figure out an animal's basic structure, you'll know how its hide or fur should grow, flow, or drape.

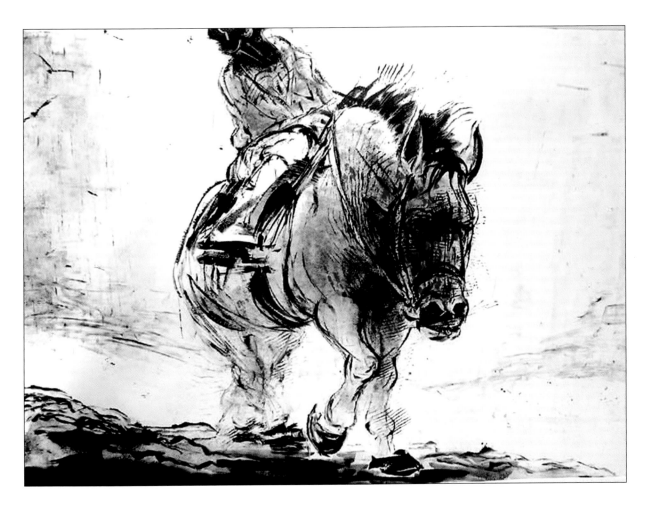

Try to use lines that match the direction and texture of the fur or hair. Drawing fur on bears, or warts on a rhino's hide, can be approached in a similar way to drawing fields in a landscape: by creatively using different kinds of marks, lines, and textures to describe different forms.

If you want to add fur or hide-texture to an animal without muddying the big light and dark shapes of your drawing (covered in Chapter 3, Composition, page 29), try **incorporating texture into your shading**.

AUTHOR'S NOTE: As a child growing up in New York City, I used to think that my borough, the Bronx, covered the whole world, that all places on earth looked like the bleak city blocks of my neighborhood, and that the only place you could escape to was the Bronx Zoo. The Bronx Zoo to me was a magical place where I could slip out of the reality of my life into a kind of dream world. We lived in an apartment on Bronx Park South, right across from the zoo, and my grandfather used to take me and my older brother there quite often when he was out of a job.

I loved all of the animals, but was especially drawn to the massive ones, such as elephants and rhinos. The rhinos in particular fascinated me with their armor, thick skin, huge horns, and warts. They looked like creatures from another planet. Years later I was delighted by an invitation to include my work in a portfolio of prints displayed at the Bronx Zoo. The prints were later added to the zoo's permanent art collection. The animal I was chosen to depict was the rhino.

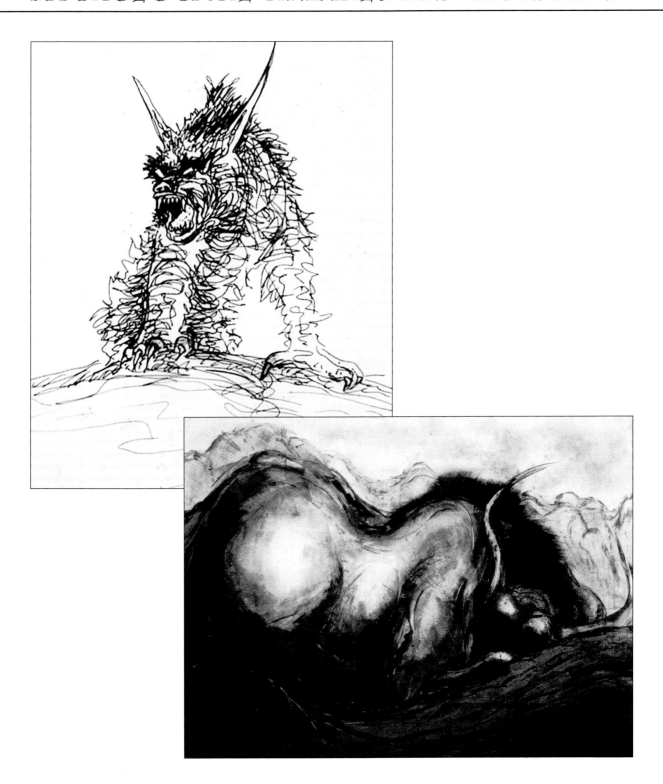

The illustrations above are samples of imaginary creatures constructed by mixing up body parts from different animals, in combination with imaginary drawing. You can create fantastical beasts—chimeras, dragons, and other mythological animals as well as your own inventions—by referencing the bodies of real animals.

EXERCISE: Draw an animal

Find a photo of an animal you've never drawn before and draw it using the methods outlined in this chapter. Reduce its body to simple lines and shapes, and let them guide you.

Then, if you have the opportunity, try drawing from life. Don't worry about getting every detail at first. Just focus on capturing the overall gesture and shape of the animal.

CHAPTER 13
INSPIRATION GALLERY

On the next few pages are some finished pieces I show to my classes throughout the semester. If you're stuck for drawing ideas, flip through and see if a subject, mood, or concept strikes you.

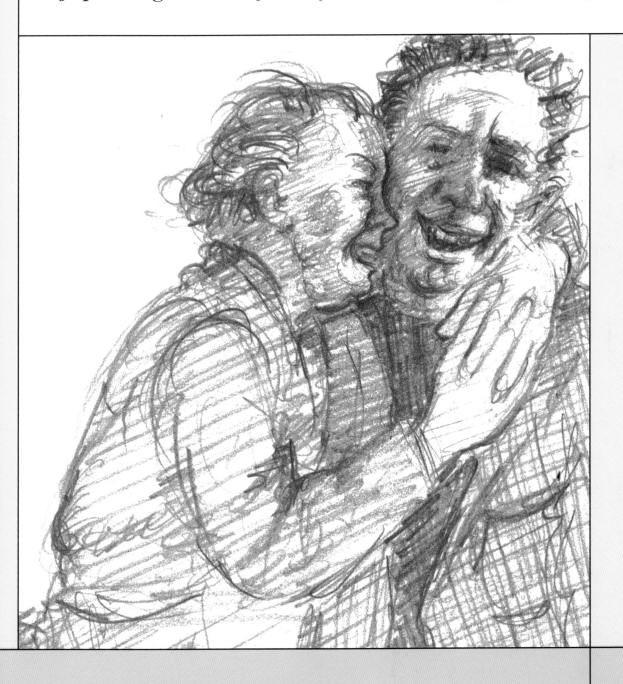

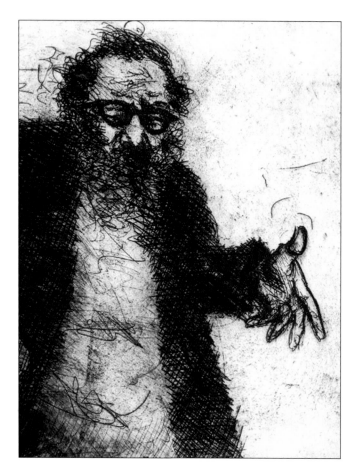

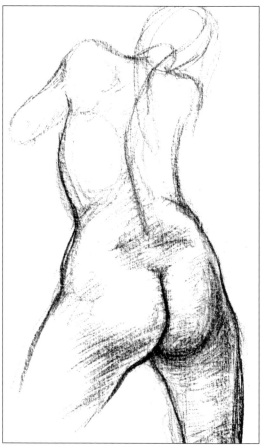

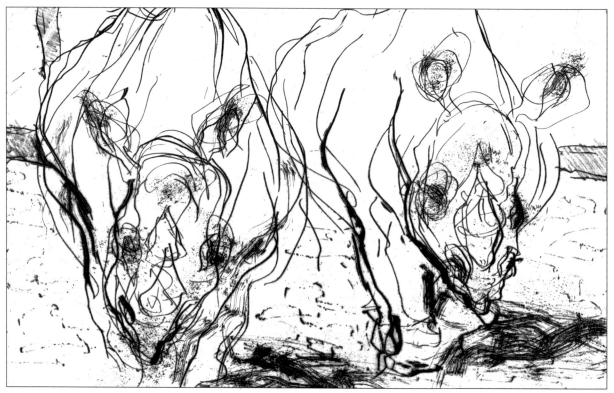

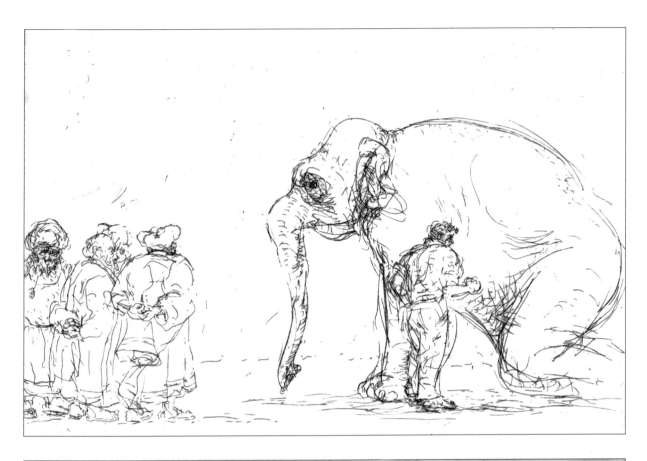

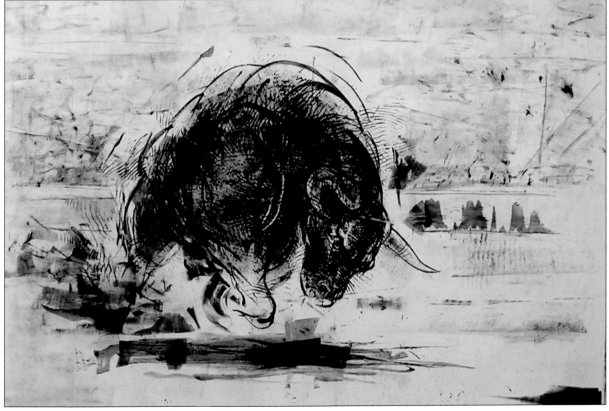

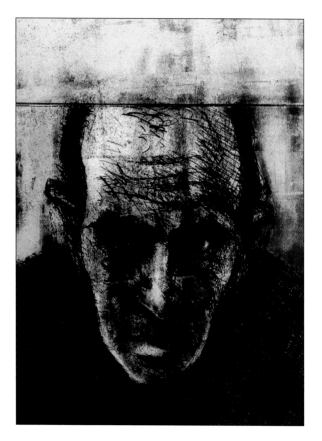
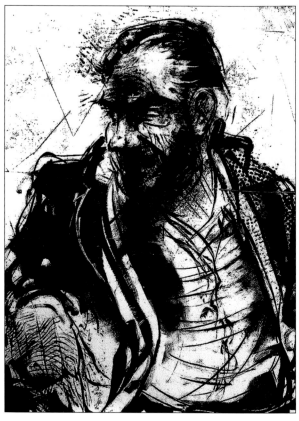
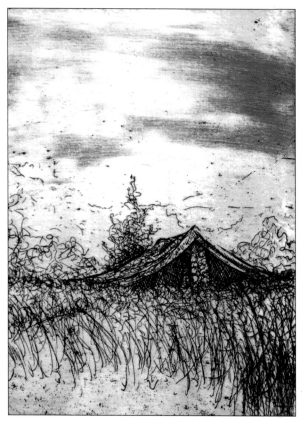

Acknowledgments

I really want to thank Talia Levy and Suzanne Schwalb for all of their great guidance, knowledge, and support on this project. It was a pleasure and a great learning experience for me to work with them.

Thank you: Sharon Shiraga, Harry Waldman, Samantha Waldman, David Waldman, Faith Boyarin, Russ Spitkovsky, Tom Woodruff, David Rhodes and the whole Rhodes family, Marshall Arisman, Shiro and Catherine Shiraga and the whole Shiraga family, Bryna Waldman, Neil Waldman, Abre Chen, Lisa Santalis, Stephen Fredericks, Sarah Sears, Jahee Yu, Gunars Prande, Dominick Rapone, Sarah Varon, Shannon Broder, Panayiotis Terzis, Alejandro Chen Li, Carl Titolo, Brooke Larson, Michael Kovner, Elana Goren, Nu Ryu, Kirsten Flaherty, Matt Barteluce, Daniel Barteluce, Sara Barteluce, Phil Sanders, Akiko Takamori, Keren Moskovitch, Paloma Crousillat, Joseph Cipri, Christine Morrison, Charles Yoder, and Larry Wright.

A special thanks to Barbara Lalicki and Joe Gyurczak.

About the Author

Bruce Waldman is a printmaker, illustrator, and college art instructor who works in the New York City area. He has been an adjunct professor at the School of Visual Arts for more than 30 years, is a member of The Board of Governors of the Robert Blackburn Printmaking Workshop, and is a director of The New York Society of Etchers. He has also been an adjunct professor at the Westchester Community College Center for the Arts for more than ten years, and teaches at the College of New Rochelle. Bruce has given intensive seminars at Korea University in Seoul, South Korea, the Robert Blackburn Printmaking Workshop in New York City, and the Printmaking Center of New Jersey, where he is also on the Board of Directors. His prints are in the permanent collections of the Metropolitan Museum of Art in New York; the New York Public Library; the Art Institute of Chicago; the Bronx Zoological Museum; the Royal Collection, London; the New York Historical Society; the Library of Congress, Washington DC; the Housatonic Museum of Art, Connecticut; the New York Transit Museum; and the Museum of American Illustration at the Society of Illustrators.

Bruce created the cover artwork for the 1990 national bestseller *Iron John* by Robert Bly, and for *Primate Behavior* by Sara Lindsey, the 1997 finalist for the National Book Award for Poetry. His illustrations for *Piracy & Plunder* by Milton Meltzer won the Silver Medal in the book category at the 45th annual Society of Illustrators exhibition in 2004. He illustrated posters for the Utah Shakespeare Festival's productions of *Death of a Salesman* and *Hamlet*, and created *Phantom of the Opera* art published in *People* magazine when the play premiered on Broadway. He has illustrated more then 20 books, including seven for the Franklin Library.

Bruce worked as senior creative director and medical illustrator for Science and Medicine, the medical education division of D'Arcy, Masius, Benton & Bowles, for 16 years. He is one of the co-founders (along with Russ Spitkovsky and Matt Barteluce), contributors, and art directors of *Carrier Pigeon* magazine, a fine art publication. He is on the Board of Directors for Guttenberg Arts, a non-profit art organization and studio that houses *Carrier Pigeon*.